POSTCARD HISTORY SERIES

Somerset County

IN VINTAGE POSTCARDS

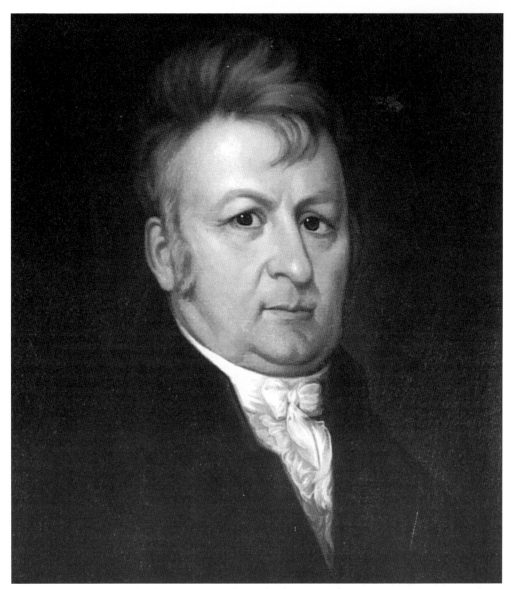

GOV. LEVIN WINDER. The first governor of Maryland to come from Somerset County was born September 4, 1757, the son of William Winder. At the outbreak of the Revolution he joined the Army as a first lieutenant. An excellent soldier, he was promoted immediately and attained the rank of lieutenant colonel by the time of his discharge. A staunch Federalist, Winder was appointed a major general of the militia by Governor Lee in 1794. In 1806, he began his elective career in the House of Delegates from Somerset, and two years later, he was selected as its speaker. On November 23, 1812, as an anti-war Federalist, Winder became governor. He pleaded with the national government for help against invasion; his pleas were ignored, and he was forced to rely on Maryland and her native sons to defend the state. Marylanders responded, and at Baltimore the British were defeated. Winder was re-elected each year until the war was over. He was also elected grand master of the Masons of Maryland while governor and laid the cornerstone of the Washington Monument in Baltimore on July 4, 1815. He died July 1, 1819, at age 61 and was buried in Monie. (Courtesy of Poplar Hill Mansion; photograph by Edward F. Deacon.)

POSTCARD HISTORY SERIES

Somerset County

IN VINTAGE POSTCARDS

John E. Jacob and Jason Rhodes

ARCADIA

Published by Arcadia Publishing,
an imprint of Tempus Publishing, Inc.
2 Cumberland Street
Charleston, SC 29401

Printed in Great Britain.

Library of Congress Catalog Card Number: 2001090845

For all general information contact Arcadia Publishing at:
Telephone 843-853-2070
Fax 843-853-0044
E-Mail sales@arcadiapublishing.com

For customer service and orders:
Toll-Free 1-888-313-2665

Visit us on the internet at http://www.arcadiapublishing.com

CONTENTS

ACKNOWLEDGMENTS

We wish to thank the Somerset County Library System for its helpfulness in lending us its microfilm files and the *Marylander and Herald,* and for allowing us to take them out of the library. We also wish to thank the Wicomico County Library System for making its microfilm reader available to us so that we could make notes on the microfilm files' contents. Without this cooperation, this book would have been much less interesting and less factual.

Our thanks also go to Bobbi Jean Mister, Jessica Anderson, James Jackson, and Frank Rhodes for opening their collections to us. Their assistance went a long way toward making this book complete. We also wish to thank Mrs. Ellen Britton and the Fairmount Academy Foundation for their kindness in lending us pictures of Fairmount. We acknowledge the help that we received from Ted Phoebus, clerk of court for Somerset County, who graciously answered our questions. We also wish to thank Miles Rhodes for his assistance in providing information on some of the scenes depicted in this book. Last but not least, we wish to thank Norris "Scorchy" Tawes for making his private collection available to us.

Where no credit is given for pictures, they are from the private collections of the authors.

INTRODUCTION

Somerset County was proclaimed a county in the Colony of Maryland in 1666. It originally covered the current Somerset County area, as well as today's surrounding counties of Worcester and Wicomico in Maryland, and lower Sussex County, Delaware, and encompassed more than 16,000 square miles.

The first Englishmen happened upon the area now known as Somerset as early as 1608, when legendary explorer Capt. John Smith explored the region, finding Native Americans he believed to be violent savages. Accounts from a little more than a decade later show that Captain Smith's initial analysis of the area may have been incorrect. By the 1620s, settlers were trading with Native Americans throughout the area now known as Maryland's Eastern Shore, including Somerset County.

In 1661, a group of Quakers preparing for exile from Virginia received approval from Lord Baltimore Cecilius Calvert to relocate to the southeastern part of Maryland. At the time this area was only sparsely inhabited by settlers, most of whom had gathered to form two villages—Manoakin, which is now Revell's Neck, and Annemessex, just outside what are now the city limits of Crisfield. That same year, records show that two African Americans—Anthony and Mary Johnson of Accomack, Virginia—settled in Manoakin. They are believed to have been the first free African Americans in Maryland.

Upon its proclamation in 1666, the county in which the villages of Manoakin and Annemessex were settled was named Somerset, in honor of Lord Baltimore's sister Lady Mary Somerset. Though peace with Native Americans was broken on occasion, the settlers remained, for the most part, friendly with the Native Americans during the county's early years. In 1693, Charles Calvert, third Lord Baltimore, commissioned a flag to be designed for Somerset, combining the image of a Native American and the British flag. That flag remains in use today.

By 1701, the county boasted more than 5,000 English residents. Agriculture was the county's prime source of income, and popular crops at the time included corn, wheat, oats, and perhaps most profitable, tobacco. In 1742, part of Somerset's land was taken to form a new county, Worcester. The division turned roughly one half of Somerset's residents in to Worcester County residents. The first school in the county, Somerset Academy, was established at Westover Plantation in 1767, with 80 private students.

In 1774, a militia was set up in the county for protection against British troops. What is said to have been the bloodiest battle of the Revolutionary War occurred 16 years after America declared

its independence in 1776. On November 30, 1782, barges from Somerset and Accomac Counties lined up near Kedges Strait to blockade the British Navy from Somers Cove, where the British planned to establish a military base. The effort, known as the Battle of the Barges, was successful, and the British were unable to gain land in Somerset County.

By 1790, the county had grown to more than 15,000 residents, and more would come with the introduction of the railroad to the area in the mid-1800s. Today, Somerset County continues to thrive, with agriculture, seafood, production, and tourism industries at the forefront. Though some say the county's better days are behind it, with declining industries and traditions some of today's concerns, others say that today's rapid technological advancements and other improvements in the quality of life indicate that the best is yet to come.

This book is dedicated to the history of Somerset County by way of the postcard, a popular form of communication in Somerset and all of America since the late 1800s. Though postcards in some of the county's less populated areas are difficult to come by, nearly every part of the county was represented in the postcard form at some point or another.

One
PRINCESS ANNE
TO 1910

*P*rincess Anne was founded in 1733 as a place for the county seat of Somerset after the creation of Worcester made the former country seat, located on Dividing Creek, inappropriate. Lingering legal issues over land ownership and rights prevented lots being sold in Princess Anne for a number of years. Princess Anne was already the county seat before these lots could be put on the market. It was in this period that cart wheels and horses' hooves had widened Main Street near the river to 84 feet. This slow start and the lack of a navigable river probably set the stage for Princess Anne's leisurely growth.

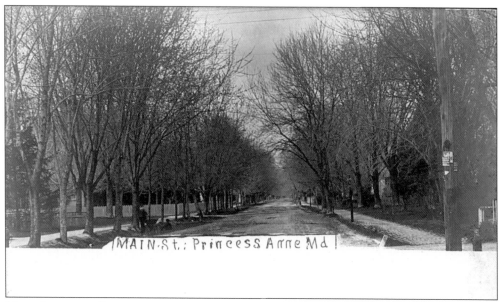

MAIN STREET IN PRINCESS ANNE. Exuding an air of slow-moving peace and quiet, this picture shows no traffic on the street—not a horse, not a carriage, not a pedestrian. The trees on the left are evenly spaced, and the sidewalk on the right is made of brick. This was a lazy country town.

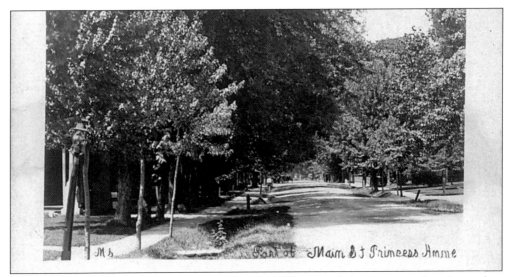

PART OF MAIN STREET, PRINCESS ANNE. This pre-1907 postcard view appears to have been taken from the middle of the block south of Washington Street, and a congregation of horse-drawn vehicles is in the background. A street intersection is on the left with a fenced-in area behind it marking the Boxwood Gardens. In 1912, Princess Anne voted to borrow $10,000 for sewer and water improvements. Since this image pre-dates that time, fireplugs are shown. They were installed in the water line every 400 feet, enabling firemen to attach their hoses and release streams of water on fires.

ON THE MANOKIN RIVER. Postmarked April 6, 1909, this postcard depicts the home of John W. Crisfield in the upper right and the lane leading to it on the left. Crisfield's home was situated on Deal Island Road, and the lane just past the Red Bridge. The lane curved to the left to serve a second house. (Courtesy of James Jackson.)

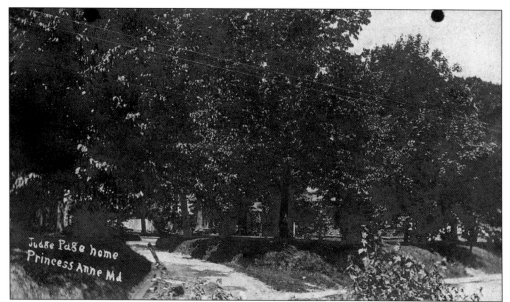

JUDGE PAGE HOME. Here, the lane curves to the left and to the home of Judge Page, the son of John Crisfield. Crisfield's wife was an only child, and when she died, Crisfield allowed her father (his father-in-law) to adopt his son so they could keep the name alive. Crisfield was always close to his son, and Page's house, seen above, was next door. Page was a member of the legislature, a state's attorney, and a judge of the Court of Appeals. He died in 1912.

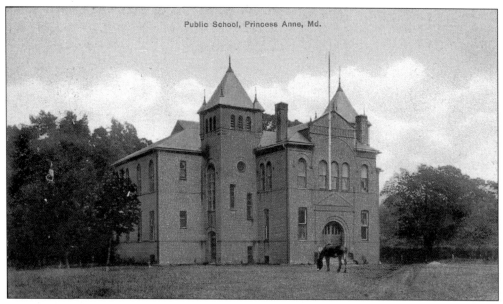

Public School, Princess Anne, Md.

PUBLIC SCHOOL. This school was built in 1891, using bricks from the old Academy, which was built in 1802. Located west of the Beechwood Estate, the public school housed both high school and elementary school students. Five new classrooms were added in 1917. In 1926, a new elementary school was built, and this building housed only the high school. It continued to be used in this way until the new high school was erected north of the Presbyterian church. This postcard was published in 1909 by B.H. Dougherty, the first owner of the Auditorium.

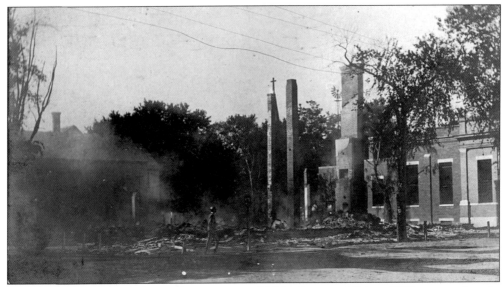

THE BURNT DISTRICT. The southwest corner of Main Street and Prince William, seen here in early September 1907, was devastated by a fire that burned the store of W.O. Lankford and Ross, Miss Jennie Jones' Millinery Store and residence, and the drug store. The Peoples Bank of Somerset, on the right, failed in 1933, and the county commissioners bought the building at auction for $4,160. It now houses the office of the county treasurer. This view was probably photographed by E.I. Brown, whose store was across Main Street. (Courtesy of Janet Carter.)

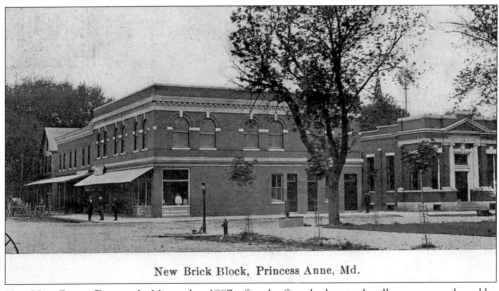

New Brick Block, Princess Anne, Md.

THE NEW BRICK BLOCK. In November 1907, after the fire, the lots to the alley were purchased by Randolph S. and Edward Herman Cohn, who erected the present building that has arched windows and a decorative cornice. Occupied by many tenants through the years, the building's longest lasting was the Colborn Pharmacy. The next building was constructed by W.O. Lankford. It had a 50-foot frontage, and Lankford occupied the entire building. Lankford sold the business to A.S. Yoffie in 1924 and the building to the Kirchners. Yoffie used only half of the building. He operated the business until 1927, when he went into bankruptcy.

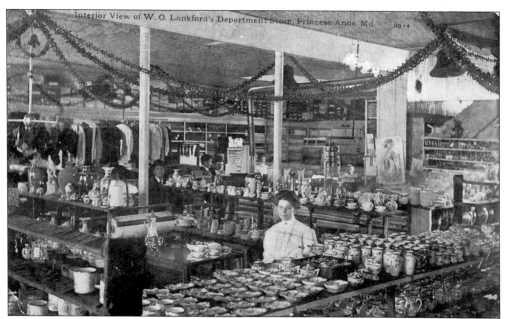

INTERIOR VIEW OF W.O. LANKFORD'S STORE. W.O. Lankford began in business about 1899. This picture is likely of Lankford, standing near the left pillar, and his wife, in the foreground. Christmas decorations are up and the store is loaded with merchandise, so this is probably Lankford's new store and the picture taken in 1908. Lankford sold out of his business in 1924 and moved to Washington. But, he missed his old friends, and so returned in 1927 and died that same year.

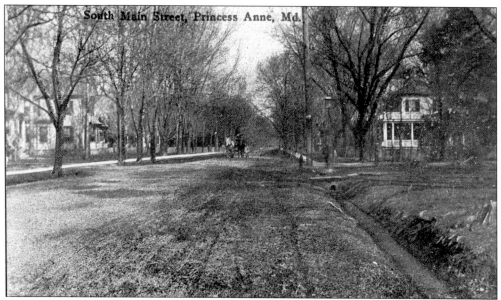

SOUTH MAIN STREET. Now renamed Somerset Avenue, the unpaved street seems to have enormous width. This is partly because the sidewalk, as well as the water system, ends at Linden Avenue. The last fireplug can be seen on the right. The houses on both the right and the left are still there, but both sit behind high hedges now. The house on the right is the Waters House, which was built just before the Civil War.

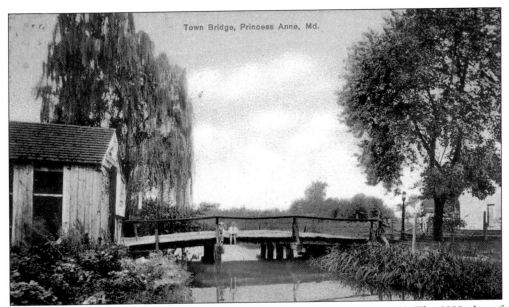

Town Bridge, Princess Anne, Md.

TOWN BRIDGE. The bridge and its predecessors have been in place since 1742. The 1899 plan of the town shows the bridge, as well as a building on the north side of it and a house on the south side, without identifying the use of either. The Manokin River divides just east of the bridge into two prongs, and a road led to crossing and on to the college. This latter bridge was called the Bombay Hook Bridge. A new bridge over the east crossing was built in 1917, which moved the connection to Broad Street and cost $989.96.

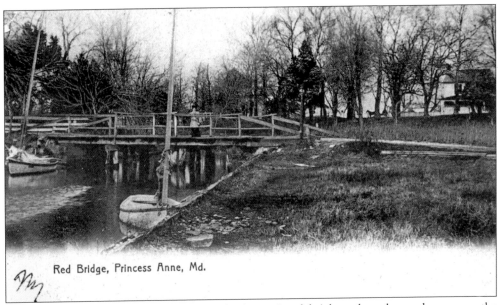

Red Bridge, Princess Anne, Md.

THE RED BRIDGE. Originally, a covered bridge, painted bright red, took travelers across the Manokin River on the road to Deal Island at this location. This newer bridge retained the old bridge's name. The river makes a U-turn here, and Crisfield's farm home, called Edge Hill, is visible in the background. Crisfield lived here after his bankruptcy and left it to his widow. The house burned in 1984.

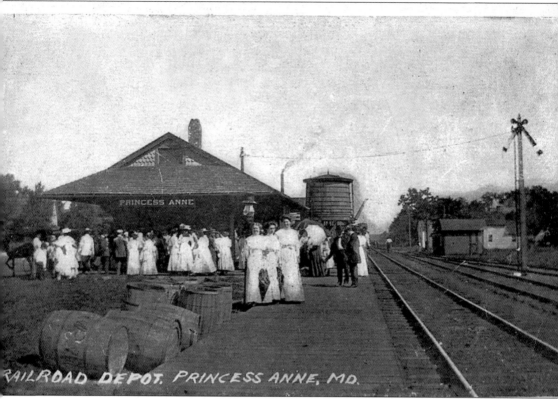

RAILROAD DEPOT, PRINCESS ANNE, MD.

RAILROAD DEPOT. This is actually the second depot, built in 1890. The ladies in their white dresses are probably on their way to a temperance meeting. This building was donated to the town library and moved to Church Street, opposite St. Andrews. When the library outgrew it, it was sold as a residence and moved again. H.H. Dashiell had a canning factory on Depot Street, and the buildings shown on the right are probably those. The water tank has disappeared from later pictures.

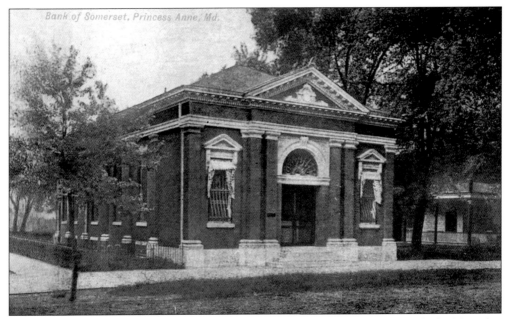

THE BANK OF SOMERSET. The bank was organized in 1899 and had its office in the building that is now Tony Bruce's law office, where it remained until 1903, when the building pictured above was constructed on the opposite side of the street. The Bank of Somerset existed until 1975, when it merged into Peninsula Bank. Since the merger, the company has built onto both sides of the original bank.

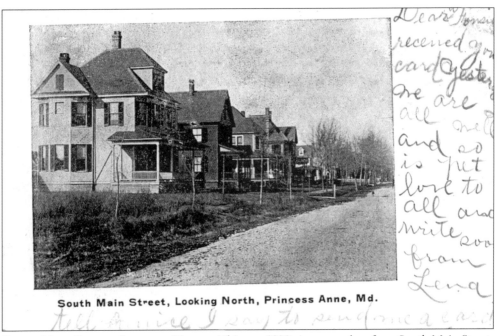

South Main Street, Looking North, Princess Anne, Md.

SOUTH MAIN STREET, LOOKING NORTH. This pre-1908 view was taken from South Main Street, looking north toward Hampden. There is a large brick house on the corner now, but the rest of the houses are all there. The fourth house is now the Somerset Apartments.

Two

PRINCESS ANNE

BEFORE AND AFTER

*A*ge is generally connected with debility, but in Princess Anne, it means affability. The celebration of Old Princess Anne Days is the time when the town wears its best bib and tucker, puts its best foot forward, and becomes a genial host, opening its doors for all to enjoy. Visitors and residents alike enjoy the Teackle Mansion, with its wings spread out at the head of Prince William Street; the Washington Hotel, occupying a prominent place on Somerset Avenue; Manokin Presbyterian and St. Andrews Episcopal Churches, with their ancient histories; and the Tunstall Cottage, with its clear connection to the original plat of the town. All are within easy walking distance of the courthouse and all contribute to the charm of Princess Anne and its history.

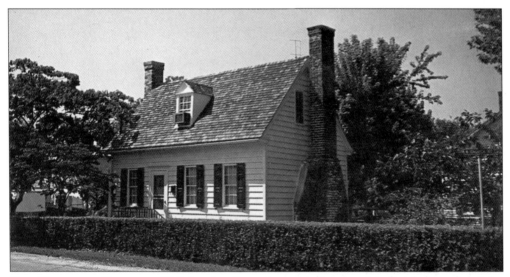

THE TUNSTALL COTTAGE. This lot, Lot 7 on the original town plat, first belonged to John Tunstall. It was later resold to William Geddes, who built the cottage pictured above around 1755. Geddes moved to Chestertown and conveyed the property to Isaac Handy for £240. At the time of the federal assessment of 1798, the home was owned by Isaac's son, Richard Handy. In recent years it has been owned by John H. and Maud Jeffries. Maud was the founder of Old Princess Anne Days, and John was county chairman of the National Bicentennial Celebration. When the Jeffrieses bought the property they found the home's original beams still in place in the basement, adzed on the top side and bark-covered on the under side. The Tunstall Cottage is probably the oldest house in Princess Anne.

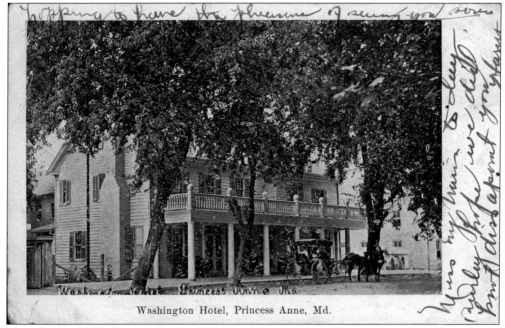

Washington Hotel, Princess Anne, Md.

THE WASHINGTON HOTEL. John Bell, a barber and peruke maker, had a tavern license in Dividing Creek during the time when it was the county seat. When Princess Anne was made the county seat in 1742, Bell switched his business address and bought Lot 15 on Bridge Street. He erected a tavern and sold it to Henry Waggayan in 1752. The building has been a center of hospitality and conviviality ever since, but when the structure took on its present appearance is uncertain. It is clear, however, that the name "George Washington" became attached to the hotel in 1856. George Alfred Townsend, author of *The Entailed Hat*, stayed at the hotel and wrote part of his manuscript while there. An addition to the hotel was erected in 1910-1911. Mary Murphy is the present gracious hostess at the Washington Hotel.

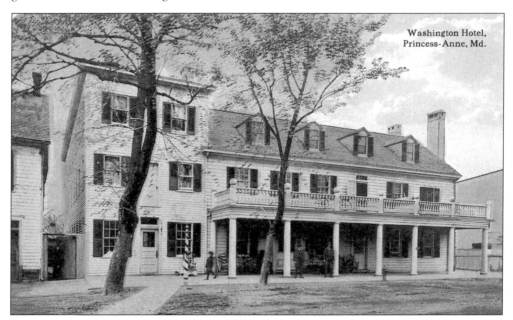

Washington Hotel, Princess-Anne, Md.

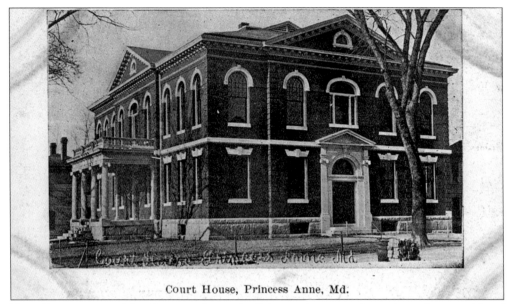

Court House, Princess Anne, Md.

THE COURTHOUSE. The first courthouse in Princess Anne was located on the east side of Somerset Avenue and the north side of Broad Street. The one pictured here is the third courthouse, constructed in 1905. In this picture the grass has been recently planted, and stakes employed to keep people off the new lawn are visible. Electricity came as a Christmas present to Princess Anne in 1915, but the courthouse was not wired. We suppose the commissioners thought that electricity was just a "flash in the pan" and didn't want to waste the taxpayers' money. However, a year later, satisfied that electricity was here to stay, officials spent $255 to have the building wired and fixtures installed on the second floor.

THE WOOLFORD-ELZEY HOUSE. This house was built about 1790. It is located on North Somerset Avenue, south of the Manokin River adjoining the city park. It is recognizable by the steps up to the city pavement in front of the house. There is also a ground-level entrance to the basement on the north side of the dwelling.

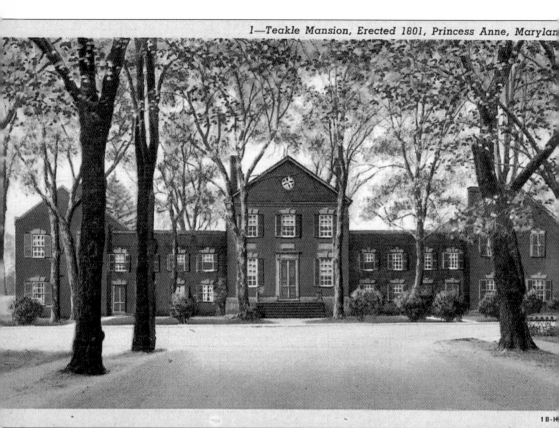

1 B-H

TEACKLE MANSION. Built of brick laid in Flemish Bond, the Teackle home is imposing, standing as it does at the west end of Prince William Street. It has double doors in the center section with a set of steps leading to them. Inside the mansion are mirrored windows on the east side of the main room and false doors. A stairway on each side of the center section leads down to the floor level of each wing. The center section was built in 1803 with the wings added in 1819. Littleton Dennis Teackle, the builder of the edifice, was a man with impressive ideas and a number of businesses. Unfortunately, he never planned for depressions, only unending prosperity. Elected president of the Eastern Shore Railroad, Teackle did not start at Elkton and build south, so that as each segment was completed it could produce revenue. Instead, he began by acquiring rights-of-way in Somerset. He bought the whole property in his daughter's name, then got the right-of-way for the purchase price. When a depression hit, Teackle had no money left. His fellow directors fired him, but it was too late. The railroad had to be abandoned in 1839.

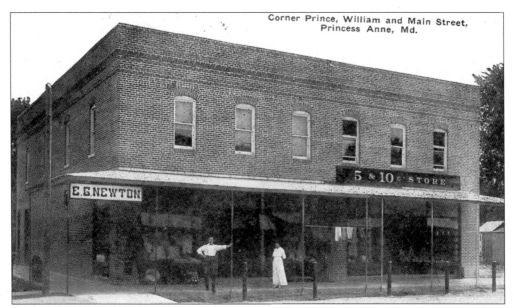

E.G.NEWTON

5 & 10¢ STORE

CORNER OF PRINCE WILLIAM AND MAIN STREET. E.G. "Egg" Newton started his grocery store on the southeast corner of Main and Prince William around the turn of the century. This picture was taken after the fire of December 30, 1913 destroyed the frame building where he did business. Newton had to rebuild, this time with brick. Newton and his wife pose in front of the new building. The 5¢ and 10¢ store next to it was then run by O.C. Holland and I.A.H. Morgan. Newton was dedicated to his work. He could not stay out of the grocery business, and though he sold out twice, he restarted three times.

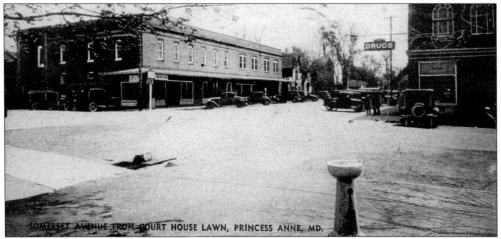

SOMERSET AVENUE FROM COURT HOUSE LAWN, PRINCESS ANNE, MD.

SOMERSET AVENUE FROM COURTHOUSE LAWN. This 1930s picture shows the extension of the Newton building along Somerset Avenue, the drug store on the southwest corner, the paved streets, and the installation of a water fountain by the Rotary Club. Mrs. E.G. Newton persuaded her husband to let her start a hat shop, then to add women's wear, and finally, to have a full department store. When two stores became vacant, Newton acquired the Chrysler-Plymouth agency to fill them, and later, when another became vacant, added that space to the auto business. In 1939, Newton died, leaving his wife in charge. She got rid of the auto agency, but within three months had a gift shop, and by 1942, another department store.

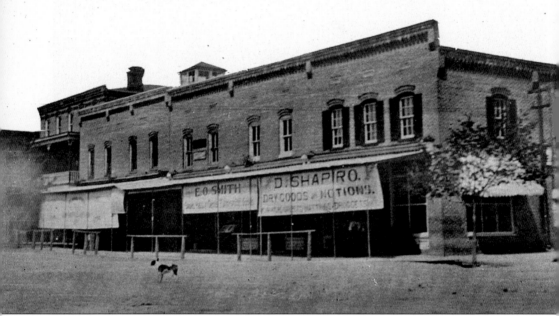

MAIN STREET. This 1910 picture of the northwest corner of Prince William shows four buildings; the first, on the far left, is a three-story brick hotel sold by Col. P.D. Baker to S. Frank Dashiell in 1913. Dashiell bought the building to convert it into a mercantile business. He soon tired of storekeeping and sold out of the business in 1920, retaining ownership of the building. In 1925, Dashiell sold the building to W.P. Fitzgerald, who proposed to start a movie theater. Fitzgerald remodeled the building with two stores in front and the entrance to the theater in the middle. Movies were shown in the rear and partly in the basement. Fitzgerald named the theater The Preston—his middle name—and J. Earl Norris became the manager. In 1932, Norris bought the building and Auditorium and, in 1937, changed the name to The Princess Theater. The second building in the picture above was the drug store of T.J. Smith. It operated until 1931, when George Colborn bought it and removed his drug store from the Cohn building, consolidating the two stores. Colborn installed a new soda fountain immediately. The third building in this view was the home of Miss Ella O. Smith's millinery store. She operated it until she retired in 1928, at which time she sold her stock and the building to Mrs. G.W. Beahler. Mrs. Beahler kept the store only a year and then sold it to H. Edwin Morris, who opened a menswear store. The corner store in this picture was that of D. Shapiro. He sold it in 1912 to Mrs. Teresa Goodman because of ill health, and she operated it as The Busy Corner until her death in 1932. The building was sold the following year to Sidney Hayman. After that, it became the home of Dougherty and Hayman's Drug Store.

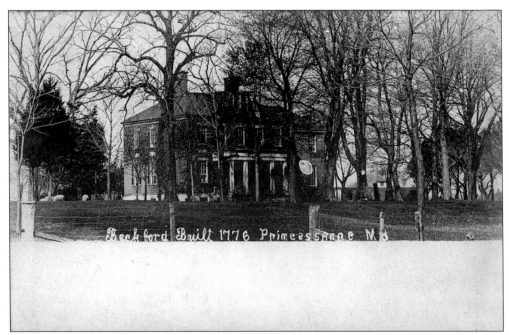

BECKFORD. The Federal-style and beautifully crafted Beckford was constructed about 1805 rather than in 1776, as shown on the card above. It was built by John Dennis, a congressman and later senator, who had barely had a chance to sleep in the house when he died in 1806. The Dennis and Lankford families owned Beckford for nearly 200 years. About 1850, a two-story addition was constructed on the north side. A real ornament to Princess Anne, the home had an elaborate barn with living quarters above it and a crisscrossed fence between house and barn. Both are now gone. The picture below shows the enclosed porch, which has been added to the front entrance without marring it. Beckford faces Beckford Avenue and is visible from both Mansion Street and U.S. 13.

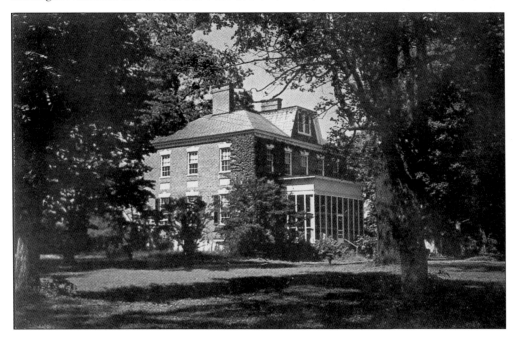

THE LIBRARY. The Somerset County Library, pictured here, was in the old Presbyterian Lecture Hall from 1958 to 1959. This building was constructed in September 1862 and has been available for community use. The Baptists used it for both church and Sunday school when they were attempting to form a congregation in 1916. The library was first housed in the original railroad station, which was built in 1890, but was later moved to a lot in the rear of the Bank of Somerset, opposite St. Andrews Church. At that time, the library had between 1,500 and 2,000 books, and Miss Amanda Lankford was the librarian. Today, the library has a multi-roomed brick building and is located on Beechwood Street at the edge of the downtown area.

NUTTERS PURCHASE. Recent architectural research has shown that this house was not built until about 1800. The chimney, partly concealed by the trees, served two fireplaces, one in the one-story section, the other in the story-and-a-half section, each at a different elevation. The house was built as the tanner's house, and the low land by the river held the tanner's various vats. A separate vat was required for each kind of leather, and the length of time each vat had been soaking was carefully charted so that the leather in each was fully tanned. Shoe soles and uppers required different lengths of times in soak. Littleton Dennis Teackle owned the tanyard from 1804 to 1816.

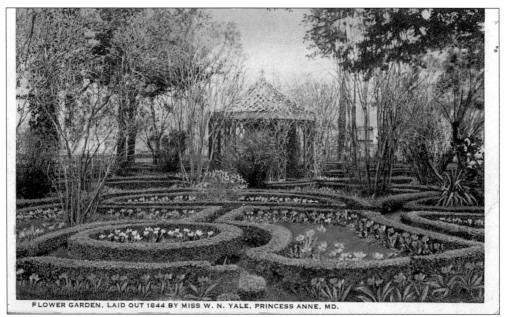

FLOWER GARDEN, LAID OUT 1844 BY MISS W. N. YALE, PRINCESS ANNE, MD.

FLOWER GARDEN LAID OUT BY MISS W.N. YALE. This is primarily a boxwood garden, laid out by Elizabeth Handy, the wife of Gen. George Handy. A clause in an 1870 deed states that "on said lot and piece of ground no house or building shall be built during the lifetime of said Elizabeth Handy or within five years after her decease." This puts the beginning of the garden back more than 200 years. An article in the *Somerset Herald* on July 24, 1991 reports that a crepe myrtle in the garden was the largest in the state with a height of 34 feet and a trunk circumference of 2 feet, 5 inches. The tree has since been removed. There is no record of a Miss W.N. Yale owning the garden, but a record does exist showing ownership by a Mrs. Elizabeth Handy Gale from 1893 until the property was sold to Alfred P. Dennis. The house shown in the background of the picture below is the General Handy House.

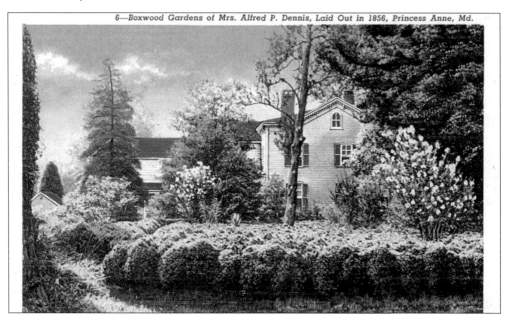

6—Boxwood Gardens of Mrs. Alfred P. Dennis, Laid Out in 1856, Princess Anne, Md.

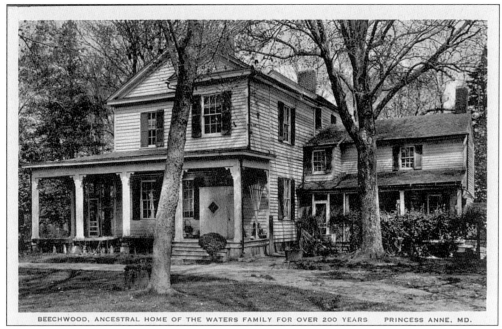

BEECHWOOD, ANCESTRAL HOME OF THE WATERS FAMILY FOR OVER 200 YEARS PRINCESS ANNE, MD.

BEECHWOOD. This postcard says that this building has been the ancestral home of the Waters family for over 200 years—this is almost true. Four acres were purchased by William Gillis Waters for $100 on March 11, 1806, and the property was retained by the Waters family for many years. But it was finally sold to American Legion Post 94 and is now, after much alteration, their meeting place.

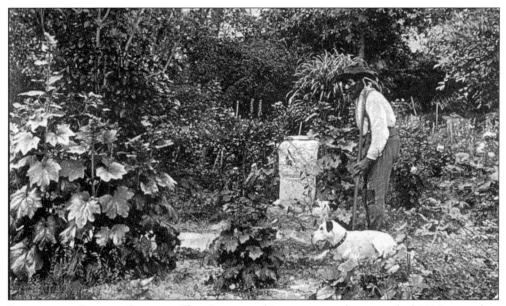

BEECHWOOD FLOWER GARDEN. The picture on this rare postcard, postmarked 1908, was taken and published by E.I. Brown, a local photographer and jeweler. The main house is shown in the background, and in the center of the picture is the family gardener, consulting the sundial and accompanied by the family dog. The garden is lush with plants and flowers.

26

PRINCE WILLIAM STREET. Two houses are shown in this picture. On the north side is the side hall–double pile Josh House, an acronym of the owner's name. The home was once owned by Hampden H. Dashiell, who went bankrupt in the canning business in November 1928. A full view of the structure can be seen upon entering Princess Anne from Deal Island Road and turning left onto Mansion Street. The Italianate-style house on the south side is the Francis Barnes House, later the home of Judge Henry L.D. Stanford. After Stanford owned it, the home, which has an imposing center hall flanked by a parlor and dining room, became an elementary school for the first five grades. It went back to being a house after the elementary school building was constructed.

THE GATE HOUSE. This house, at the corner of Beckford and Prince William Streets, and the one across the street were built about 1805 to mark the entrance to the Teackle property and to serve as quarters for the servants of the Teackle family. The buildings were the last properties Littleton Dennis Teackle owned when he was forced to sell the mansion. The property was sold to Joseph F. Smith, who, with his heirs, owned it until 1897.

THE WILLIAM W. JOHNSON HOUSE. Built in Federal style in 1835, this home is located on the corner of Somerset and Antioch Avenues and is listed on the National Register of Historic Places. It has a classical front entrance with an arched fanlight. Owner William W. Johnson was a prominent citizen, an ardent Episcopalian who financed the building of the bell tower of St. Andrews Church.

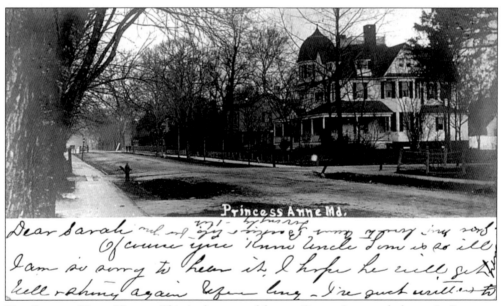

THE JOSHUA MILES HOUSE. This is the most elaborate Queen Anne–style house in Somerset County. It has a three-story octagonal tower on the north side, a wraparound porch, and a palladian window on the west front corner over a second-floor porch. The home was built by Joshua Miles to show his importance—he was an attorney, a bank president, and the Democratic boss of Somerset County. He was also appointed the federal collector of internal revenue for Maryland by Pres. Woodrow Wilson. After some decades as a private home, the Joshua Miles House is now occupied by the Hinman Funeral Home.

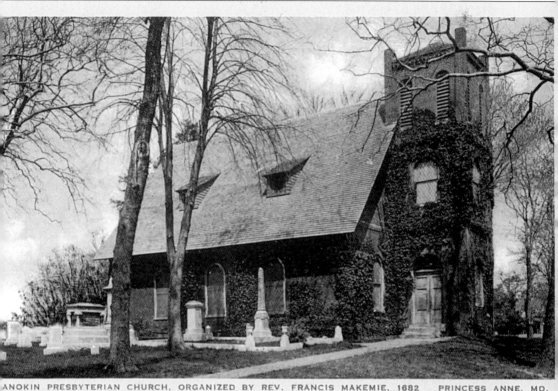

MANOKIN PRESBYTERIAN CHURCH. The antecedents of this church go back to 1672, when the grand jury called Robert Maddox to preach on the third Sunday of each month at the home of Christopher Nutter, who lived at the head of Manokin River. In 1683, Francis Makemie arrived and formally organized the congregation at Manokin. In 1764, the congregation decided to build a brick church, 50 feet by 40 feet, that cost £600. In 1872, the church was rebuilt, and in 1888, a three-story bell tower was added at the east end. An education building was constructed alongside the church in 1950. This building is also brick, built in Flemish Bond, but without the glazed blue headers.

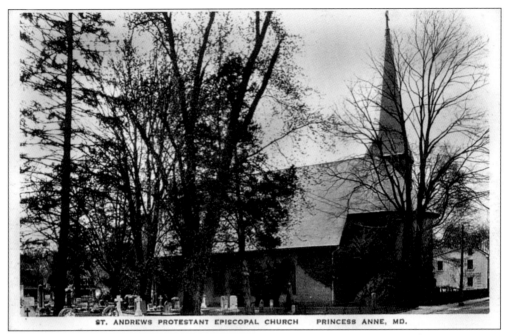

ST. ANDREWS PROTESTANT EPISCOPAL CHURCH PRINCESS ANNE, MD.

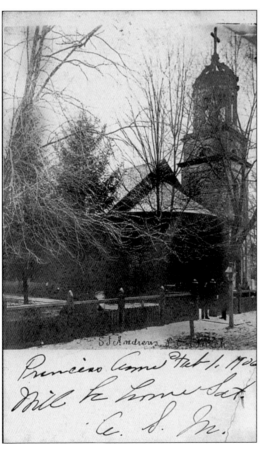

ST. ANDREWS EPISCOPAL CHURCH.

Robert Geddes sold Lots 27 and 28 of the original town to Somerset Parish on February 17, 1767. St. Andrews was completed in 1770 as a chapel of ease, and the walls and gallery from the original structure remain. In Paul Touart's book, *Somerset: An Architectural History*, a *c.* 1900 picture shows the tower spire and the new, unbroken roof over the chancel. The postcard to the left, although mailed in 1906, is obviously older. The broach spire was built in 1896, and the picture on this postcard precedes that, showing the tower as it was when built in 1859.

Three

PRINCESS ANNE
AFTER 1910

*S*ince 1910, Princess Anne resembles many other towns in that it built new schools and other buildings, paved *roads, constructed bridges, had fires and rebuilt with brick or stone, started new businesses, and built new dwellings. Princess Anne did all these things, but with only half of its attention. The other half was directed to putting new bathrooms in old houses, modernizing kitchens, converting stables into garages, putting new show windows in stores, adding new wings to homes to accommodate new needs, installing new organs in churches, and converting large homes into apartments. Most of the houses that were torn down were replaced by filling stations or garages. Princess Anne is a town comfortable with its antiquity.*

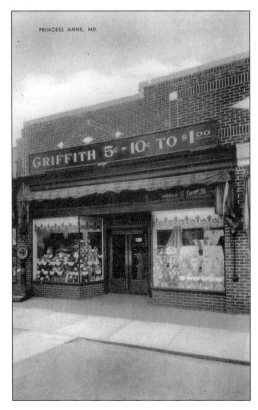

GRIFFITH 5¢ TO $1. D.H. Griffith's was a single-store operation. He went into business in the Kirchner Building in 1932 and was still in business in 1942. During that time, Griffith served as president of the Businessmen's Association. During part of that time, he competed head-to-head with Fox's, an Eastern Shore chain. Griffith probably carried this postcard for sale in his store.

31

ANTIOCH METHODIST EPISCOPAL CHURCH. Antioch was founded in 1852. It was remodeled in 1875, and a brick tower was built at the northeast corner. When the congregation found that tower structure was unstable, it was torn down in 1895 and a new bell tower built in its place. The residence on the left is the parsonage. In 1913, Thomas M. Bock made a challenge gift to the church of $5,000, provided the congregation raised another $5,000 for a new church. They raised it, and in 1915, workmen began tearing the old church down. In May, the old church had been demolished and a contract signed for a new one that would cost $25,000. It was to be constructed of beaver dam marble and have an auditorium seating 300, a Sunday school room seating 200, and a social room, also seating 200, over the Sunday school room. On July 28, 1915, the cornerstone was laid with much fanfare, and on July 2, 1916, the dedication of the church followed.

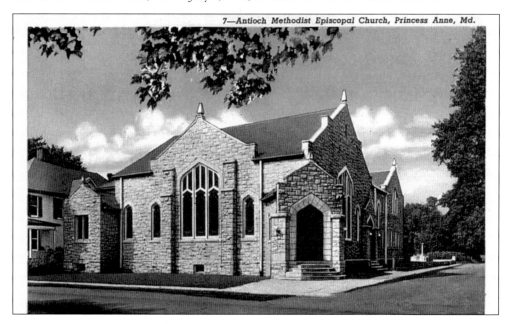

7—Antioch Methodist Episcopal Church, Princess Anne, Md.

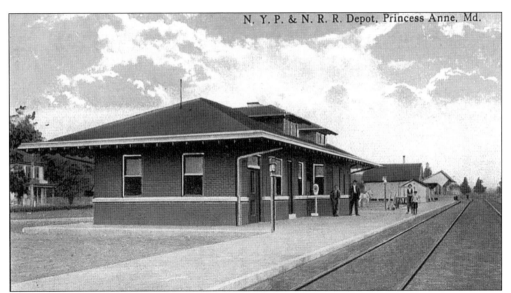

NEW YORK, PHILADELPHIA & NORFOLK RAILROAD DEPOT. This new railroad depot was a model of excellence at the time. It had all the modern conveniences (except air conditioning) and was opened about September 1, 1913. A suit was filed to stop its erection because it blocked the passage of William Street, but the suit was dismissed. The building now houses a real estate firm.

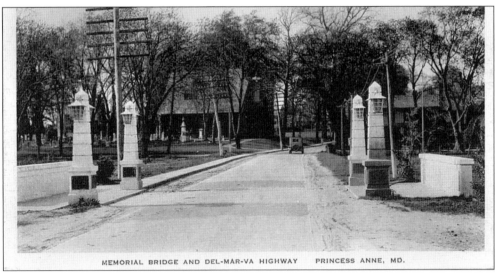

MEMORIAL BRIDGE AND DEL-MAR-VA HIGHWAY PRINCESS ANNE, MD.

MEMORIAL BRIDGE AND DEL-MAR-VA HIGHWAY. A county society, which had been formed to show appreciation to the veterans of World War I, learned that the State Roads Commission was planning to build a new bridge across the Manokin. The group decided to approach the commission to build four memorial towers on the bridge, which would hold brass plaques on which the names of every person who had served in the military during World War I would be placed. The commission agreed, provided the society agreed to pay the extra cost, amounting to $2,000. The society agreed, so the state built four extra columns, pictured here. The bridge was finished and dedicated in September 1921, but the plaques were not ready until December and a separate dedication ceremony was held. When the towers were taken down, the plaques were first taken to the firehouse, but were later sent to the American Legion post at Beechwood.

MAIN STREET AND THE AUDITORIUM. This building on the west side of Main Street housed stores on the first floor and an Auditorium on the second. The postcard above, postmarked 1906, shows the two buildings separated, while the *c.* 1915 view below shows them joined together. The Auditorium was available for all kinds of gatherings and was used as a courtroom while the courthouse was being built. It was also the site of dances, high school graduations, chatauquas, public meetings, high school and civic organization plays, traveling shows, and, of course, movies. B.H. Dougherty was the building's first owner; he also had a confectionery store on the first floor. In 1913, Dougherty added 40 seats to the Auditorium's capacity. In 1915, he bought the second building, joined them together, and added 150 seats. Another owner, J. Earl Morris also had a menswear store on the first floor and owned The Princess Theater. He ran the theater and Auditorium together but demoted the Auditorium to showing westerns on Fridays and Saturdays. He added talking pictures, but only on Fridays and Saturdays. In addition to his other activities, Morris was appointed postmaster and moved the post office into the Auditorium. The building burned down in the early 1940s.

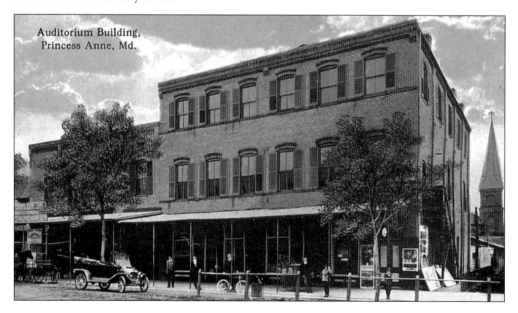

Auditorium Building,
Princess Anne, Md.

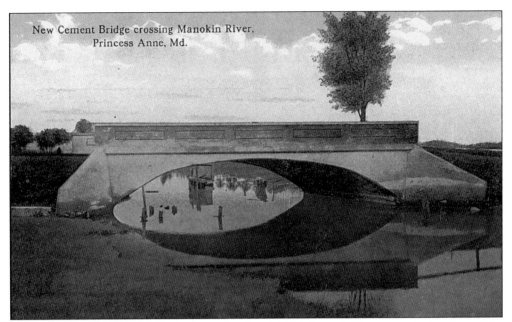

New Cement Bridge crossing Manokin River, Princess Anne, Md.

NEW CEMENT BRIDGE CROSSING MANOKIN RIVER. This is the bridge that took the place of the Red Bridge. The paved road to Deal Island was built in installments, a mile or two at a time, and the bridges at both ends were contracted for separately. The last length was completed in 1924.

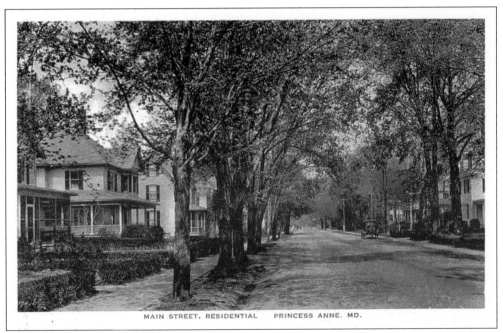

MAIN STREET, RESIDENTIAL PRINCESS ANNE, MD.

MAIN STREET RESIDENTIAL. The most prominent house on the left is that of the most prominent local individual, Judge Daniel M. Long, the circuit court judge for Somerset County. It is referred to in Paul Touart's book as the John Holland House. The next house to the north is that of Allen Muir, a city councilman.

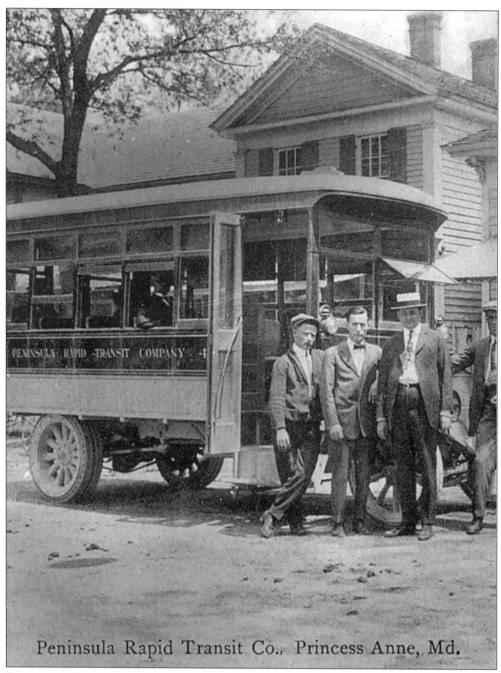

Peninsula Rapid Transit Co., Princess Anne, Md.

PENINSULA RAPID TRANSIT COMPANY. The company was organized in 1915, and its rates were 5¢ for three miles. On that basis, the fare from Princess Anne to Salisbury through Loretto and Allen would have been about 30¢. To ship packages cost 5¢ for the first pound and 1/2¢ for each additional pound. There was apparently no extra charge for distance. Leary's Lunch was the company's agent in Princess Anne. They were authorized to sell $27,000 worth of stock at $10 per share, and they bought ten busses. N.L. Mitchell of Upper Fairmount was the Somerset County director.

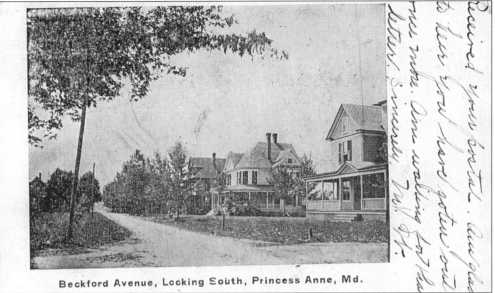

Beckford Avenue, Looking South, Princess Anne, Md.

BECKFORD AVENUE. Beckford Avenue, pictured above in a view looking north, has always been a multicultural street, and the three tenant houses of Teackle Mansion toward the north end of the street ensured that. This postcard, postmarked 1907, shows the street before it was paved and electrified; notice the absence of poles. At this time, Princess Anne was proud of the addition of fine houses and wanted to show them off. The view below was captured from the same place on Beckford Avenue, looking south. The street has still not been paved, but the line of stakes on the east side of the street shows where the curb would eventually be. Two houses, both facing Linden Street, are visible on the east side, while a street light dangles from the corner of Williams Street. The fact that the postcard was published by Colborn's Drug Store points to a date no earlier than 1928.

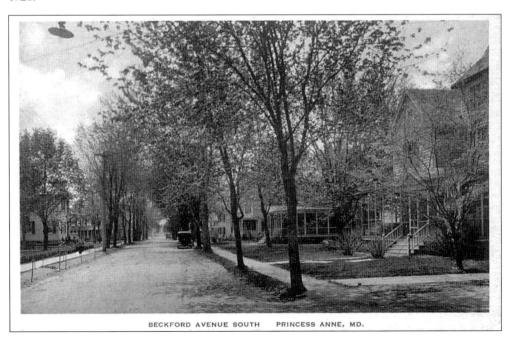

BECKFORD AVENUE SOUTH PRINCESS ANNE, MD.

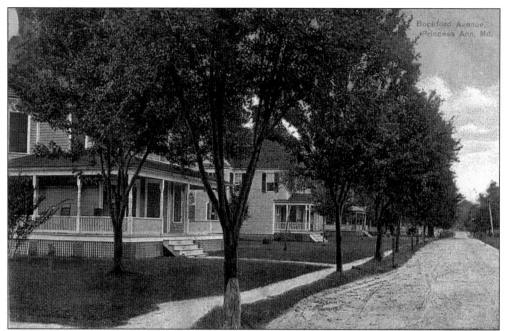

BECKFORD AVENUE. Here is Beckford Avenue north from Linden Avenue on a postcard bearing a postmark of October 23, 1913. At that time, there were only three houses on the dirt street.

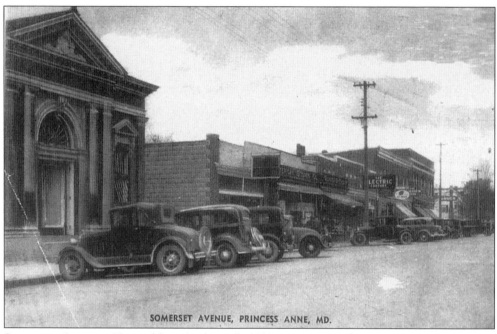

SOMERSET AVENUE, PRINCESS ANNE, MD.

SOMERSET AVENUE. Pictured here in the early 1930s, Main Street became Somerset Avenue in 1917. A drug store is on the corner of Prince William Street, the American Store is next, then a soda fountain, the local electric company, Griffith 5¢ to $1 store, and the Bank of Somerset the closest to the camera. (Courtesy of Jessica Anderson.)

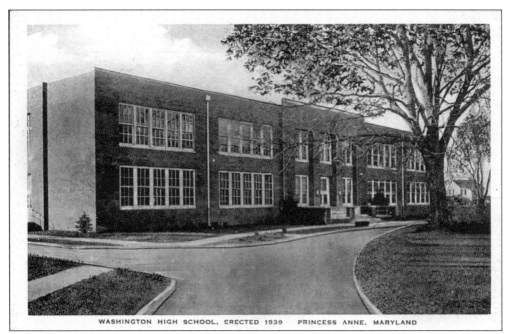

WASHINGTON HIGH SCHOOL, ERECTED 1939 PRINCESS ANNE, MARYLAND

WASHINGTON HIGH SCHOOL. This building was erected in 1939 and the old high school torn down with the help of the WPA. The new structure served as the high school, with the addition of a gym and shops, until 1979, when a new and larger school was built south of Princess Anne. The building now contains the offices of the Somerset County Commissioners and other county agencies.

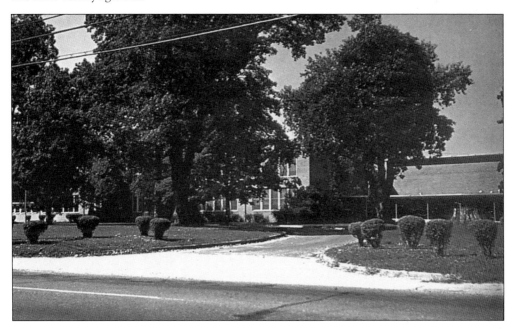

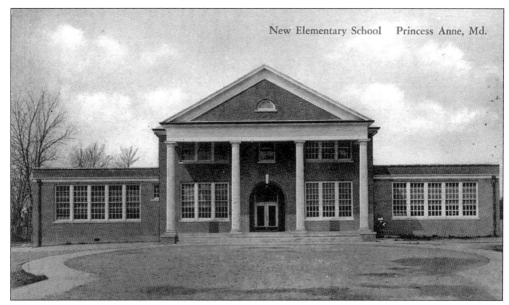

New Elementary School Princess Anne, Md.

NEW ELEMENTARY SCHOOL. The problem of financing new schools in Somerset County was solved by the county commissioners in a strange way. They let public pressure build until, in desperation, the public was willing to pay part of the cost. Members of the public pledged $15,000 toward the cost of this school. The commissioners created a Somerset Certificates Corporation, issued certificates to the contributors, then paid so much each year to the corporation until maturity, when the certificates were redeemed. The new elementary school was built in 1926–1927, and the dedicatory exercises were held on December 19, 1927. The school has now been torn down, but as seen below, it was added to before it was demolished.

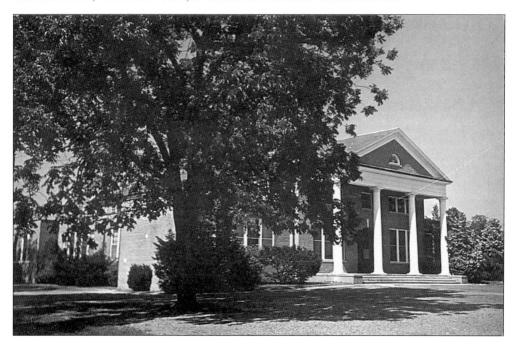

Four

THE UNIVERSITY OF MARYLAND EASTERN SHORE

The university has operated under many names since 1886, when local ministers bought 16 acres of land outside Princess Anne and opened a school for African Americans. Begun as a high school, it became a junior college and then a four-year institution with both undergraduate and graduate degrees. It has been called the Delaware Conference Academy, Princess Anne Academy, Princess Anne College, the Eastern Branch of Maryland Agricultural College, Maryland State College, and since July 1, 1970, the University of Maryland Eastern Shore. Today, UMES has a student body of 3,000, a fine faculty, and a campus of which any university would be proud.

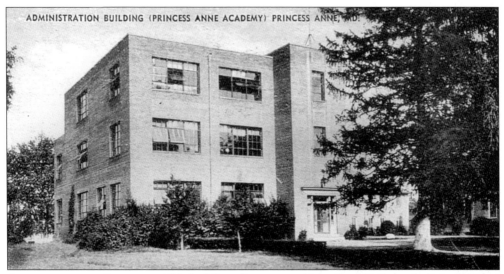

ADMINISTRATION BUILDING. This building, first renamed Maryland Hall, was built in 1940 and has been enlarged and given a facelift to fit in with the style of other campus buildings. It is still the administration building but is now named the John Taylor Williams Building.

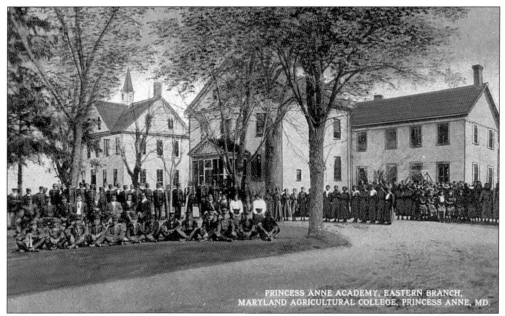

PRINCESS ANNE ACADEMY. This is probably a picture of all the people then connected with the college—staff, faculty, and students. The males are in military uniforms because the academy was part of the Land Grant-Military Training System. The faculty is behind the seated men.

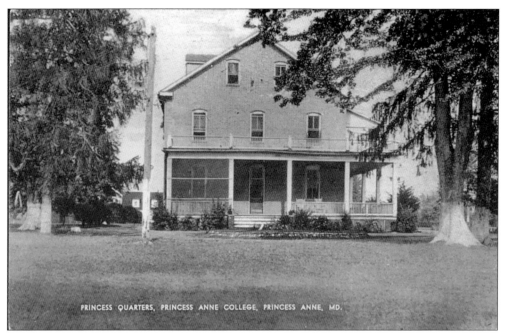

PRINCESS QUARTERS. In 1915, the year this picture was probably taken, a dormitory costing $8,000 was erected to house 150 women. It was steam heated, wired for electricity, had toilets and baths on each floor, and had a sewer connected to a drainage ditch. The college had its own water until December 1939, when it was connected to Princess Anne's water and sewer systems.

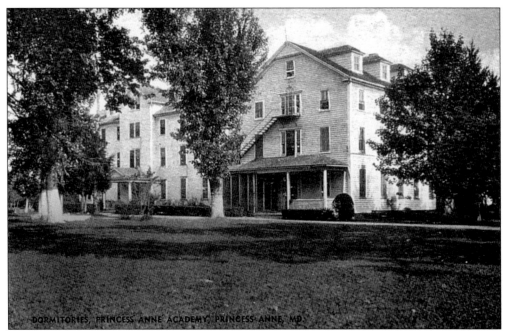

DELCON HALL. This men's dormitory was built in 1892 and was a frame building. It caught fire and was destroyed in 1959. (Courtesy of James Jackson.)

PRINCESS ANNE ACADEMY. This is how the campus looked in the 1940s. The administration building is on the left. The driveway runs straight back after passing a line of whitewashed trees, but also branches left to run past the administration building.

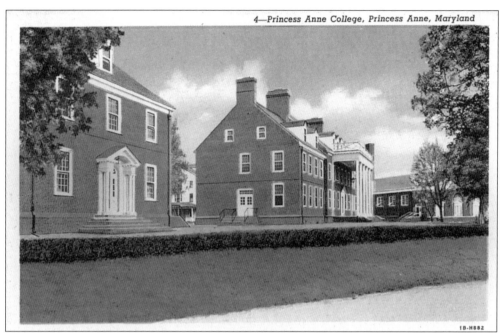

PRINCESS ANNE COLLEGE. The building in the left foreground is the Joseph Robert Waters Hall, which was built in 1950 and contains cafeteria and dining facilities. It is named for one of the school's founding clergymen.

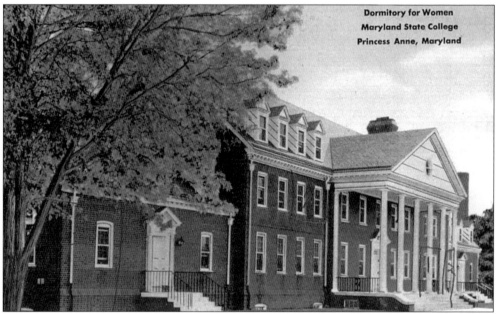

Dormitory for Women
Maryland State College
Princess Anne, Maryland

DORMITORY FOR WOMEN. Murphy Hall was built in 1943, and its annex in 1962. The present system of naming buildings had not been adopted by 1955, when this postcard was mailed, and the building was at that time simply called Dormitory for Women. It was later named for John Murphy, the publisher of the African-American newspaper. Another women's dormitory, called Nuttle Hall, was built in 1973.

44

University of Maryland Eastern Shore

JOHN TAYLOR WILLIAMS HALL. It is appropriate that the administration of UMES should now bear the name of John Taylor Williams. It was during his presidency that most of the uncertainties about the school's immediate future were resolved in a way satisfactory for UMES.

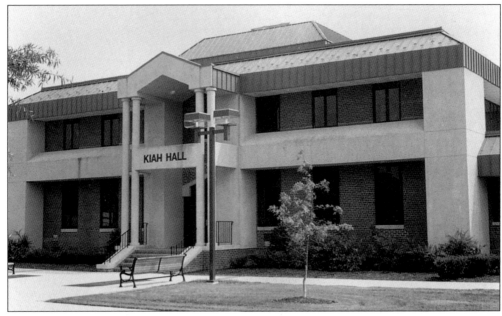

THOMAS R. KIAH HALL. Formerly serving as the African-American junior-senior high school of the county, this structure was completely renovated for the use of the physical therapy, business economics, and computer science departments. It inherited the Kiah name after the gymnasium, which originally carried it, was torn down. The university could not let Thomas R. Kiah's name be forgotten. He was the fifth head of the school and was loved and respected by both the African-American and white community. The *Marylander and Herald* reported that thousands attended Kiah's last rites.

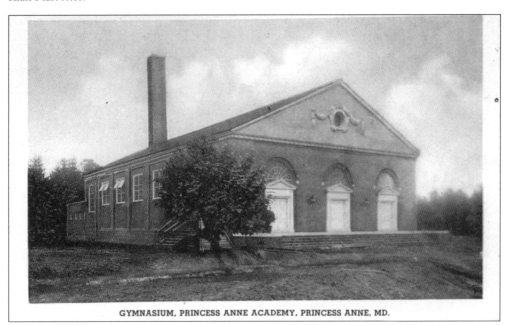

GYMNASIUM, PRINCESS ANNE ACADEMY, PRINCESS ANNE, MD.

KIAH GYMNASIUM. This building originally bore the Kiah name. It outlived its usefulness, was torn down, and replaced by the J. Millard Tawes Physical Education Building in 1967.

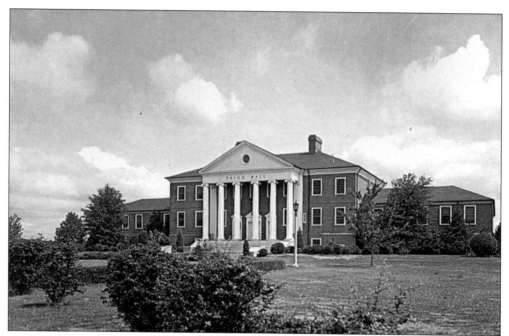

THE FRANK TRIGG HALL. Built in 1954, this structure is named after the fourth head of the institution, who served in that capacity from 1902 to 1910. It is now the home of the department of agriculture. Since it was built, wings have been added to both sides.

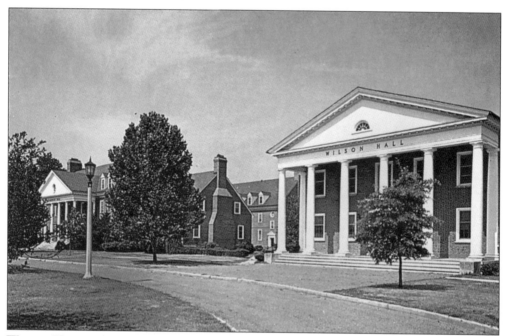

WILSON HALL AND SOMERSET HALL. Wilson Hall, named for one of the school's founders, was built in 1949. It is used for classrooms and houses the department of English and languages. Somerset Hall, on the left, was once a men's dormitory, is now a dining hall, and will be remodeled into offices.

GEORGE WASHINGTON CARVER HALL. This building, constructed in 1972, was renovated in 1990, virtually doubling the space of the department of natural sciences. The hall was named for the distinguished African-American botanist and educator.

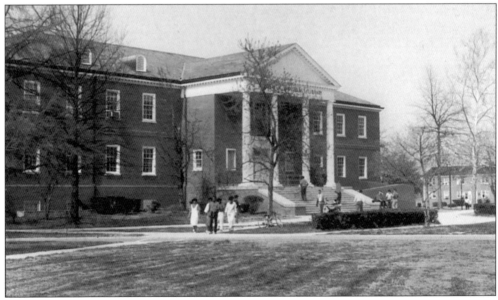

FREDERICK DOUGLASS LIBRARY. The library, built in 1969, is the heart of the university. It has over one million volumes in its stacks, including a distinguished black history collection and a history of the university going back to 1886. The library has recently been expanded and renovated and now offers audiovisuals, micromedia, and computer media.

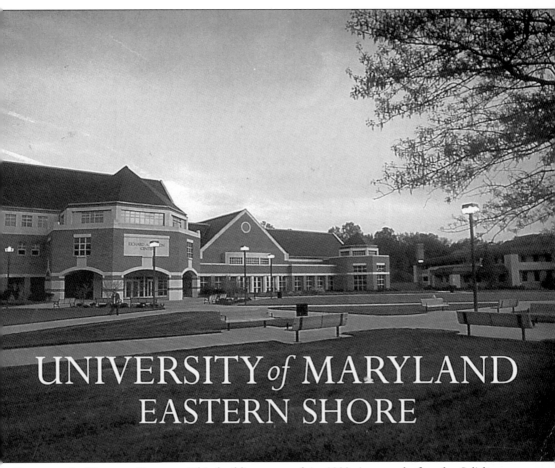

UNIVERSITY *of* MARYLAND
EASTERN SHORE

RICHARD A. HENSON CENTER. This building, erected in 1993, is named after the Salisbury philanthropist and houses the hotel and restaurant school, as well as 24 guest rooms for student practice. This school has become justly famous, and its graduates have taken over many hotels and restaurants, resulting in great improvements to their food and service.

THE ELLA FITZGERALD PERFORMING ARTS CENTER. Constructed in 1973, this building, which presides over the south side of the campus, is the home of the department of fine arts. It also contains an auditorium, which seats 1,200 people, and its name honors the famous vocalist.

THE PRESIDENT'S HOUSE. Dr. Williams was the first resident of this house, built in 1964. While not an educational building, the home has become a necessity for officials when in search of a new president. It is now one of the perks provided with the office of president.

Five

DEAL ISLAND AND NORTHERN SOMERSET

*O*riginally called Devil's Island, this piece of land had its name changed when it became the site of a Methodist camp meeting—first Deils Island, and then, with the help of the U.S. Postal Service, Deal Island. Deal Island is separated from the mainland by Laws Thoroughfare, and a bridge connects it to Chance. Until the stone road was completed and an elevated bridge built, it was often cut off from Princess Anne during the harshness of winter. The lower end of the island is known as Wenona. This chapter also deals with Oriole, Champ, Chance, Monie, Mount Vernon, and Melody Manor.

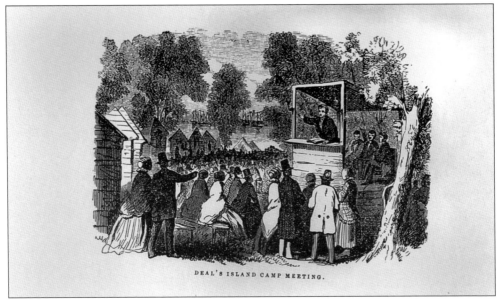

DEAL'S ISLAND CAMP MEETING.

DEAL ISLAND CAMP MEETING. This camp meeting began on July 17, 1828, and the original site was on "a bluff arising from the water's edge, thickly studded with large pine trees and accessible to visitors by land and water." This site was in use for 20 years, but, eventually, erosion dictated a new site. In August 1856, the meeting relocated to Parks Grove. Boats may be seen in the background of this engraving.

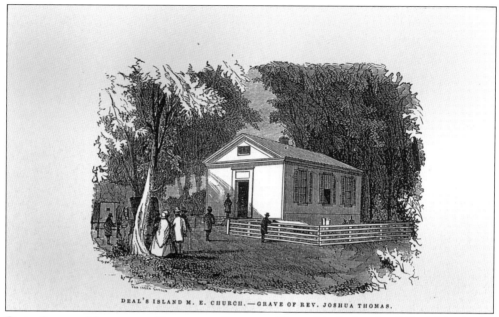

DEAL'S ISLAND M. E. CHURCH. — GRAVE OF REV. JOSHUA THOMAS.

DEAL ISLAND METHODIST EPISCOPAL CHURCH. The original church of Deal Island, this building dates to 1859. In the cemetery alongside it is the tomb of Joshua Thomas, Parson of the Isles. When the church was dedicated and a collection taken up to help pay for its cost, Thomas, who was by then a hopeless cripple whose preaching days were over, pledged his wife's cow, worth $20. Visitors from afar quietly redeemed his pledge and saved the cow. The power of Methodism on the island lasted, and in 1924, a blue law was passed, mandating that all stores, filling stations, etc. be closed on Sunday. This building is no longer the church, but serves as a Sunday school room and social hall.

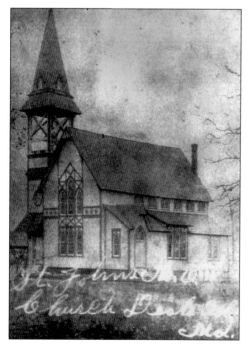

ST. JOHNS METHODIST CHURCH, DEAL ISLAND. This church was built in 1871 in front of the original building. Its outlines are the same today as they once were, but the distinctive trim has been replaced or painted over, its Victorian exuberance tamed. (Courtesy of Jessica Anderson.)

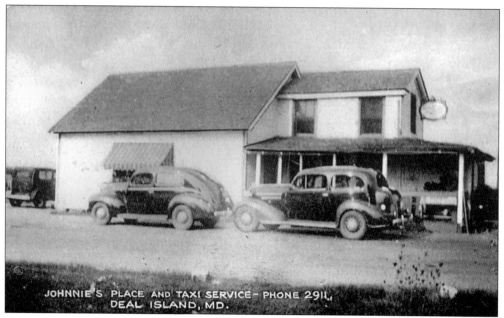

JOHNNIE'S PLACE AND TAXI SERVICE. The automobiles shown above date this view to the early 1940s, but the house shown has been torn down and the spot is now a vacant lot at the corner of Hotel Street. This is the street that led from the main road into Deal Island to the former Anderson Hotel and the steamboat wharf. Both are now washed away, but when the steamboats were running, it was a proper place for a taxi service.

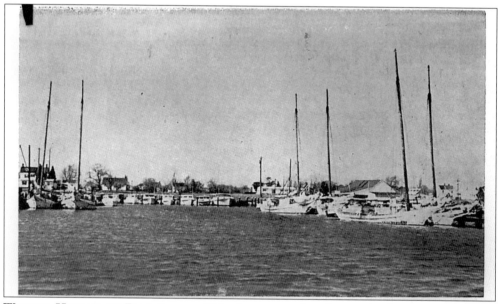

WENONA HARBOR ON DEAL ISLAND. This picture was taken from a pier that just out from the end of the point is now occupied by a row of condominiums. A low building extends from the shore on the left, but there are fewer skipjacks today to pierce the air with their masts. A woman at a nearby general store examined this postcard intently and said, "My house doesn't show, and I moved here in '75." This indicates that the postcard is at least 30 years old.

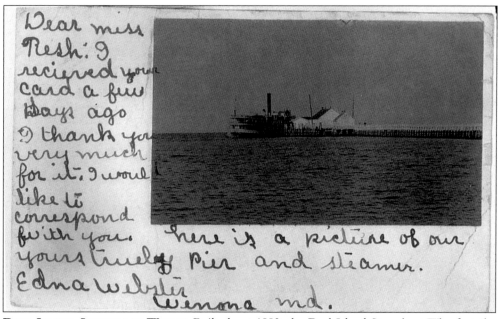

Dear miss
Nesh: I
recieved your
card a few
days ago
I thank you
very much
for it. I would
like to
correspond
with you. here is a picture of our
yours truely Pier and steamer.
Edna Webster
Wenona md.

DEAL ISLAND STEAMBOAT WHARF. Built about 1882, the Deal Island Steamboat Wharf, at the height of its activity, was served by a line from Princess Anne, the Nanticoke River Line, and the Wicomico River Line. By the end of the 1920s, steamboats were a dying breed. The Baltimore and Virginia steamship lines stopped operating on March 1, 1932. On August 23, 1933, the wharf was destroyed by a hurricane, but it was rebuilt and service resumed by the Baltimore, Crisfield and Onancock Line for a time until truck competition forced its closure. Wind and wave completed the wharf's final destruction. (Courtesy of Jessica Anderson.)

COME TO CHANCE. Chance was once called Rock Creek, and the Methodist Church there still bears that name. The community has had a post office continuously since 1882.

GREETINGS FROM MONIE. In Algonquin, "monie" means "place of assembly." There was a Native American town on the north side of Great Monie Creek and to the east of Kings Creek. Monie had a post office from 1869 to 1967.

CHAMP. All we have from Champ is this greeting card. Champ is a seafood and farming neighborhood with a boat ramp. Its post office opened on October 24, 1903, and closed on August 25, 1907, in what is now an abandoned, run-down building opposite St. Martins Lane. There is no mention of Champ in any other history of Somerset County.

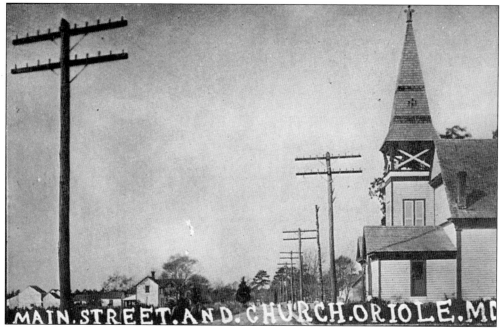

MAIN STREET AND CHURCH, ORIOLE, MARYLAND. The church at Oriole was organized in 1810. It was rebuilt and enlarged between 1869 and 1876. It was rebuilt and enlarged again in 1886, and collapsed in a storm in 1928. The parishioners decided to build again. The cornerstone was laid on July 9, 1928 and the new church dedicated on February 17, 1929.

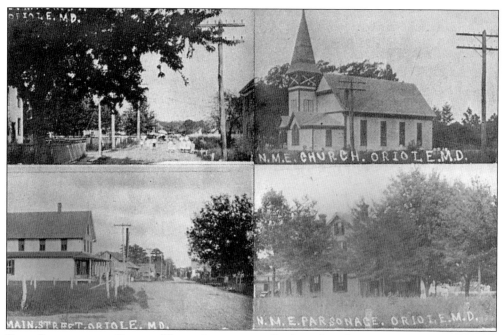

FOUR SCENES FROM ORIOLE. These pictures were all taken after electricity came to Oriole. The line was completed in October 1926.

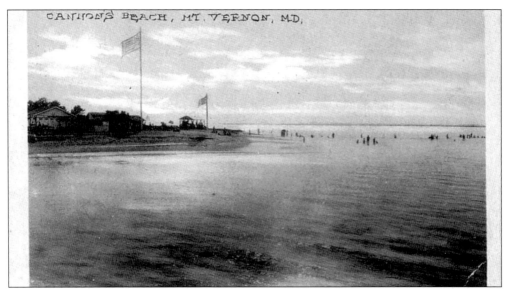

CANNON'S BEACH, MOUNT VERNON. Louis Cannon opened his beach to the public in June 1924, with a small boardwalk, a variety of food and drink stands, and a bathhouse with 100 cubicles. Cannon's beach did not meet with instant success, however, so he advertised for concessionaires. In 1925, he found two, and for the Fourth of July they advertised a beauty pageant with a $10 gold piece as first prize. Cannon sold the beach in 1928, but had to foreclose on the mortgage and take it back in 1929. In 1932, a new owner offered parcels to rent, but the lack of surf and a plethora of sea nettles, not to mention the popularity of Ocean City, finally did the beach in. Mount Vernon, an area bounded by the Wicomico River and Wicomico Creek on the north and Great Monie Creek on the south, had a post office from 1870 to 1909.

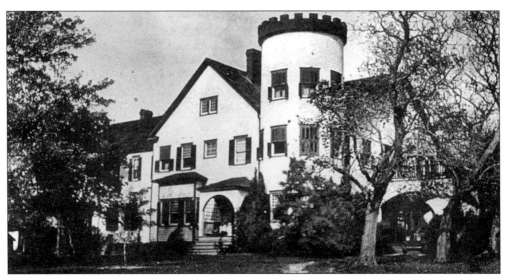

MELODY MANOR. Built around 1905, this house was designed for Ellison and Mary Van Hoose by Stanford White. It has 20 rooms and two porches facing Wicomico Creek, is covered with round-butt shingles, and was named Melody Manor because the Van Hooses had an operatic background. A subsequent owner, Robert Hupke, turned the home into a nightclub and speakeasy. After repeal business died, Hupke sold the structure at auction on June 14, 1935. (Courtesy of James Jackson.)

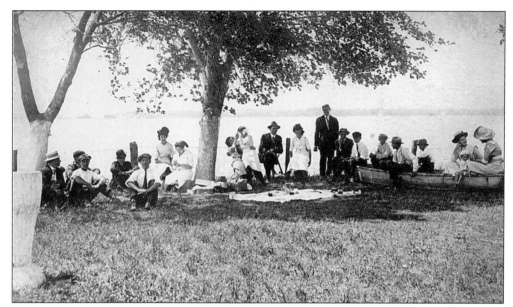

PICNIC ON THE MANOKIN. The Manokin River, which runs from Tangier Sound, is wide only at its mouth and narrows sharply as it heads for Princess Anne. This image of a picnic under a tree on the bank of the Manokin shows a group of adults, all of them in their Sunday best, and a skiff on the right that furnishes a seat for five of them. This picture could have been taken at Clifton. Notice the whitewashed tree on the left.

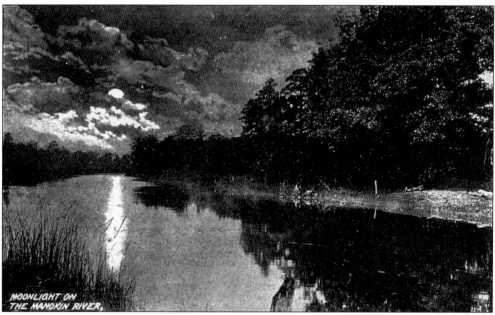

MOONLIGHT ON THE MANOKIN, PRINCESS ANNE. This postcard says Princess Anne, but the view has to have been captured below the Manokin's junction with Kings Creek, before the river widens enough to show a straight path for the moon glow. Nevertheless, in 1925, an excursion boat, 30 feet long and with room for 30 passengers, plowed the waters of the Manokin, and before that, a freighter carried freight and passengers from Princess Anne to Deal Island.

Six
CENTRAL SOMERSET

*T*he designation of "Central Somerset" is a somewhat arbitrary term, but for the purposes of this chapter it includes all of Somerset south of Princess Anne, except Crisfield and Smith Island. To enumerate, the postcards in this chapter illustrate life in Green Hill, Westover, the county to the Pocomoke River, Fairmount, Rumbley, Kingston, Marion Station, Rehobeth, and Quindocqua.

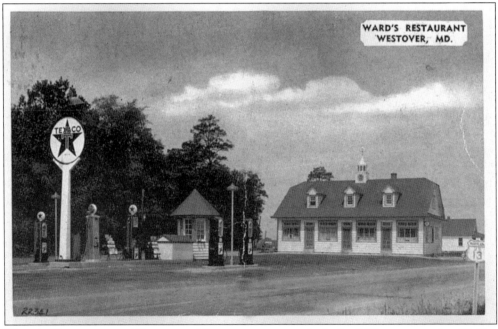

WARD'S RESTAURANT, WESTOVER. The restaurant was built in 1939 to serve the Civilian Conservation Corps camp across the road, which was turned into a prisoner-of-war camp during World War II. A new restaurant was built in 1942, and this postcard probably shows that building. Ward's Restaurant is now gone. The English Grill has also come and gone, but the Texaco station is still there.

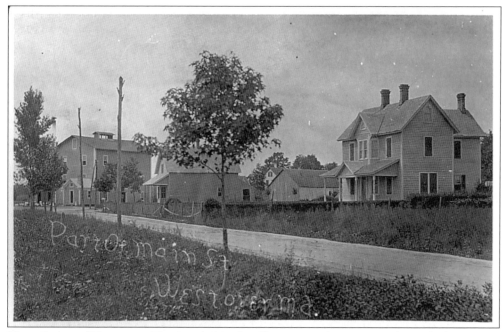

MAIN STREET, WESTOVER. The Ruark-Ritzel Mill was erected in 1876, and was the last steam-powered mill in Somerset. The owner's residence is shown. It was built about the same time, and the three chimneys tell a story about the house—no central heat.

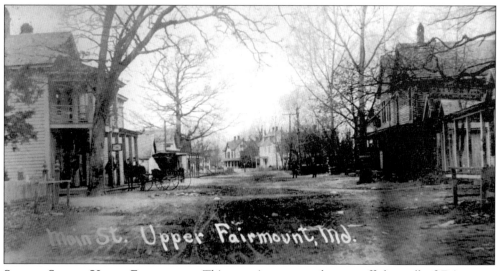

STREET SCENE, UPPER FAIRMOUNT. This one-time postcard came off the wall of Fairmount Academy and shows Upper Fairmount at the apogee of its history. At the time of World War I, the village had two lawyers, three doctors, six stores, a Mechanics' hall, and the academy. The store on the right (the building still stands) was that of E. Croswell, and the store on the left belonged to Walter White. In the background are the homes of George Windsor and Ike Ford. The last local doctor died in 1940 after having served the area for 20 years. The wartime shortage of manpower lured both men and women to the bigger cities, and they never returned to Upper Fairmount.

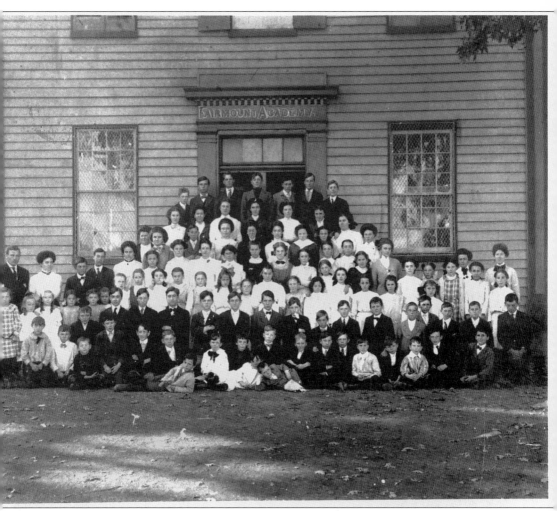

FAIRMOUNT ACADEMY. This picture shows the academy faculty, the high school students, and the elementary school students in 1909, and all but a few have been identified. The high school was closed in 1927, and the elementary school continued until 1969. At that time, the community took over the academy and elected trustees to run and maintain it. The building is now open for community events and the annual Fairmount 1800s Festival. This image was preserved by Mrs. Alice Middleton and presented to the academy.

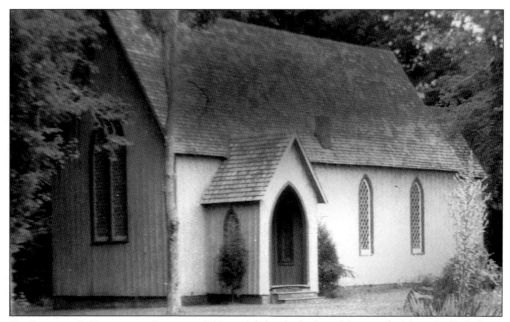

St. Stephen's Episcopal Church. This parish has had a long history of trials and tribulations. The area in which it was located was partially in Worcester and partly in Somerset when Worcester County was created in 1742. The church building was in Worcester. In 1849, the church was named St. Stephen's, and a new church was built that was only marginally successful. Finally, the decision was made to move to Upper Fairmount in Somerset County, and the church was taken apart, moved to Upper Fairmount, and re-erected and re-dedicated on January 4, 1925. However, there were too few Episcopalians in Upper Fairmount to maintain it, and the church was desanctified in the late 1950s. The building was sold, but when the new owners attempted to move it, it fell apart.

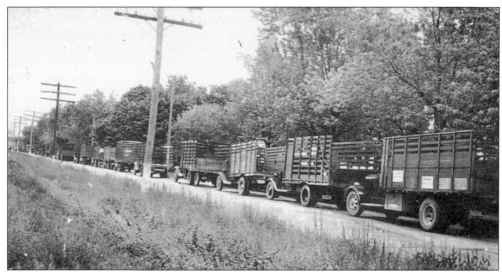

Waiting to be Loaded. This picture shows a line of empty trucks waiting to be loaded with crates of strawberries to carry to the cities. These trucks replaced the refrigerated freight car. As soon as a buyer bought the berries, he or she had them loaded on a truck and sent to its destination.

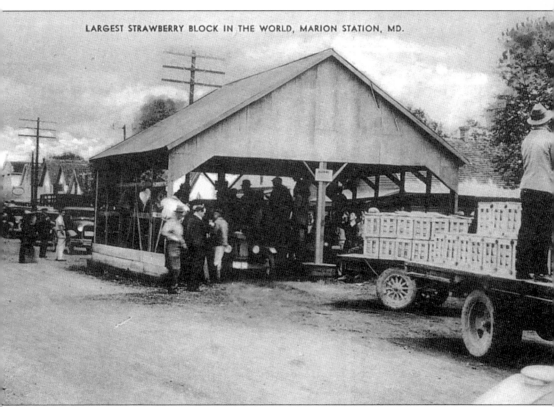

LARGEST STRAWBERRY BLOCK IN THE WORLD, MARION STATION, MD.

LARGEST STRAWBERRY BLOCK IN THE WORLD. During World War I, the strawberry made Marion Station a very prosperous community. Most farmers in the area depended on the berry for most of their income. They used tide banks and floodgates to get more acreage to grow strawberries. In 1918, strawberries sold as high as 30¢ per quart, and the strawberry was still king into the late 1930s. This picture shows the auction block where the berries were sold. During the 1930s and 1940s, many farmers went bankrupt because the price of berries became so deflated. The day of the strawberry was over, and it was replaced by the chicken.

NORTH RAILROAD AVENUE, MARION. The building on the right was Somerset Hospital, the first hospital in the county, which opened in 1908 and operated until 1917 under the direction of Dr. A.B. Allen. The two-story frame structure was altered to take care of 30 patients. It had a well-equipped operating room for the period, eight private rooms, and four wards. The structure later housed George Parson's Store from 1940 to 1977. (Courtesy of Bobbi Jean Mister.)

TRINITY METHODIST PROTESTANT CHURCH. Located on the north side of the street running east from Main Street, this church, at the time of its construction, was the largest and most costly house of worship in Marion. It was set aflame by Warfield Townsend, the "Firebug of Marion," and burned to the ground on September 3, 1924. The parsonage next door was saved because of its slate roof. Townsend's motive for burning the church was said to be some difficulty that caused his parents to withdraw from the church and join another. (Courtesy of Bobbi Jean Mister.)

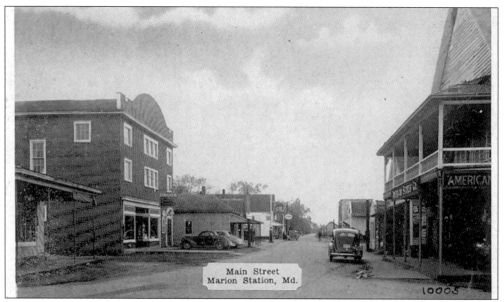

MAIN STREET, MARION. Parson's Store, pictured on the right, has been demolished, and the space is now part of the Marion Volunteer Fire Department's complex. The building on the left is the community building that was constructed in 1924. A moving picture theater occupied the upper floors, two stores were set up in the front of the first floor, and Dr. Will Coulburn's office was in the rear. The white building in the distance housed J. Stanley Adams Hardware, the oldest business in Marion. (Courtesy of Bobbi Jean Mister.)

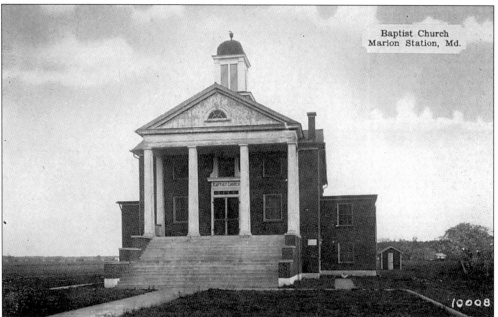

BAPTIST CHURCH, MARION. Formed in 1896, the Baptist congregation built this church, an imposing structure with four white columns and raised church floor, in 1925. Since that time the Baptists have built a new church on the east side of the highway, just about even with this building on the old road. The old building is now the home of the New Hope Christian Center.

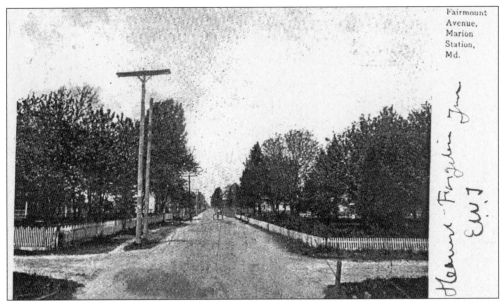

FAIRMOUNT AVENUE, MARION. Electricity arrived in Marion in November 1925 as an extension from Princess Anne. Visible in this view are only two poles going west, so electricity ran only to the edge of town when this picture was taken of the residential section west of the highway. Harding Tull and Vance Miles lived in the homes on the right.

RUMBLEY. Rumbley and Frenchtown resemble a three-tined fork sticking out into Tangier Sound. They have neither a church nor a school, but they do have county water, and Rumbley had a post office from April 4, 1905 to April 18, 1969. The son of Rumbley's last postmistress could offer no help as to where the name Rumbley came from though it was on his lot that the post office building stood, today an uninhabited building with peeling paint. These communities depend upon the bounty of the bay for their survival. (Courtesy of Jessica Anderson.)

Kingston School.

Dear Lillian, I
go to Princess A
tomorrow 12 Ocl
I am going if
you cannot
go. then Go o
the following
train, we wil
have a skea
time, A Ritz

KINGSTON SCHOOL. This school was situated on the north side of the road to Rehoboth. The Episcopal church was beyond it, and the Methodist church was on the south side of the road. The railroad ran west of all of these structures, and stores were located along the railroad. (Courtesy of Bobbi Jean Mister.)

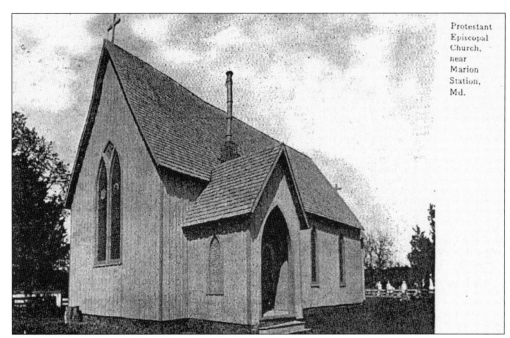

Protestant Episcopal Church, near Marion Station, Md.

ST. PAUL'S EPISCOPAL CHURCH, MARION. Built in the Gothic Revival–style, this is the oldest Episcopal congregation in Somerset County. Begun in 1726, it was relocated to this site in 1818. The building was renovated in 1894, and the entry and attached church hall were built in the 1960s, in the same style and color of the church building. The decorative fence dates to 1908.

QUINDOCQUA METHODIST CHURCH. Settlers of Quindocqua, located just south of today's Marion Station, founded the first Quindocqua Church in a wagon shop in the early 1820s. In 1847, a larger church was constructed to serve the expanding community, and the original wagon shop church was moved and converted into a schoolhouse. By 1885, the community had expanded so much that the church required structural additions (seen here). In 1913, the present Quindocqua Church replaced this building. The cornerstone at the newest church was laid September 23, 1913.

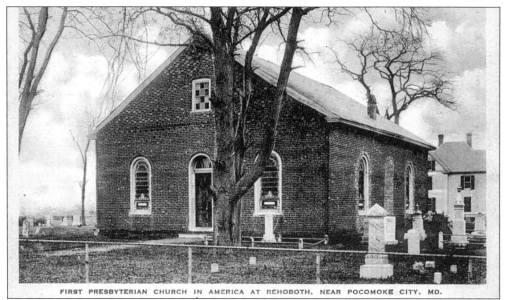

FIRST PRESBYTERIAN CHURCH IN AMERICA AT REHOBOTH, NEAR POCOMOKE CITY, MD.

FIRST PRESBYTERIAN CHURCH IN AMERICA, REHOBOTH. This church was founded in 1686 by Francis Makemie. William Stevens wrote to the Presbytery of Laggan in Ireland, asking them to send a minister to Maryland. Makemie answered the call and came and organized this church. The building was erected in 1706. In those days, Rehoboth was more important than it is now, and it was made a port of entry for Somerset in 1683. The church was renovated in 1886 and again in 1924, when it was rededicated. A new social hall was built in 1930.

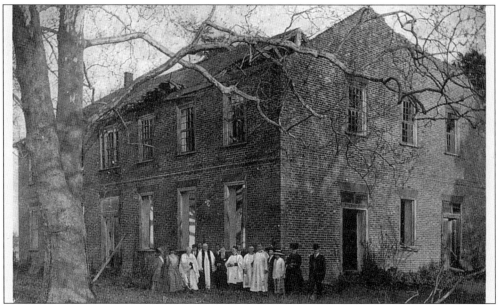

REHOBOTH EPISCOPAL CHURCH. The first church erected in Rehoboth dates to 1692. It may have been used by both Presbyterians and Episcopalians, but the church there now, of which only the remnants remain, was built in 1785. By 1900, it had fallen into disrepair, and a movement to repair it was underway but was unsuccessful. Today, only the footings are in place. In this picture, the roof is partially gone, but the walls are still standing.

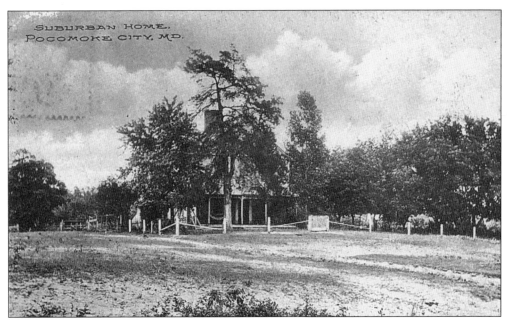

SUBURBAN HOME, POCOMOKE CITY. This house is located on Dividing Creek Road between the road and the Pocomoke River. The house was remodeled in 1940, and the porch was enclosed at that time. The home is presently owned by Mr. and Mrs. Carley Carey. Mrs. Carey, when shown this postcard, readily identified the building as the couple's home.

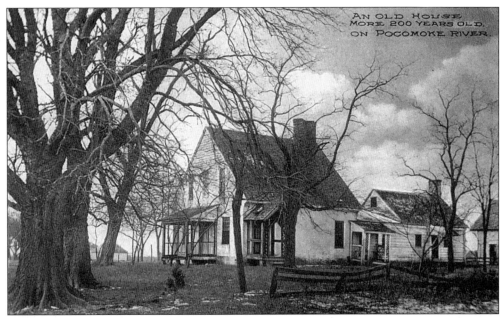

THE REWARD. This house has been dated by tree-ring analysis. Built in 1750 by Elias White at Williams Point at the mouth of the Pocomoke River, it is the only house in Maryland with diamond-stack chimneys in existence. It sits on a two-acre lawn and overlooks Pocomoke Sound from a 20-foot bank. The home was resurveyed in 1774 as Williams Green and was remodeled in 1826. It is currently owned by a Mrs. Monsell, who maintains it beautifully.

Seven

CRISFIELD TO 1927

*T*he story of Crisfield began with the Annemessex and Pocomoke tribes of the Algonquin Nation, the area's first known inhabitants. In 1666, 300 acres of land in the area now known as Crisfield was surveyed for English settler Benjamin Summers. Calling the area Annemessex, as Native Americans had named it, Summers and his family made a home in the area where Cove Street sits today. A fishing village soon evolved, taking on the name Somers Cove in Mr. Summers's honor.

Over the years, the village grew, not only in population, but also in land mass, as piles of oyster shells extended the mainland's reach out into the harbor. In 1866, with the coming of the railroad, the area was renamed Crisfield in honor of Princess Anne attorney John W. Crisfield, who had been instrumental in developing the land for the railroad. During the days of the Old West, Crisfield was known as the Dodge City of the East, complete with a number of brothels and saloons. However, the area's incorporation in 1872 helped bring about a sense of order, and by the late 1880s, prosperity began to blossom in the city.

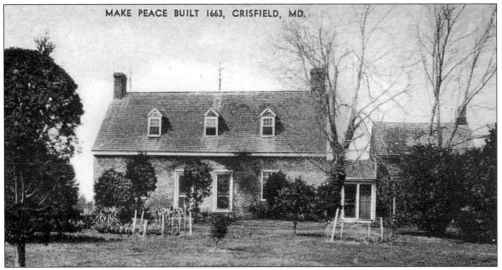

MAKEPEACE. One of the first homes built in Crisfield, Makepeace was constructed in the early 1700s by English settler John Roach on a parcel of land patented in 1666. Though the Native Americans inhabiting the area were said to be peaceful, treaty meetings were held at Makepeace following the death of a white settler, allegedly at the hand of a Native American. The meetings helped bring about the brick mansion's name. Architecturally, the building is know for the glazed header diaper, or diamond-shaped pattern on its west end. The original building, with some additions, still stands as a private home in Crisfield's Down Neck section.

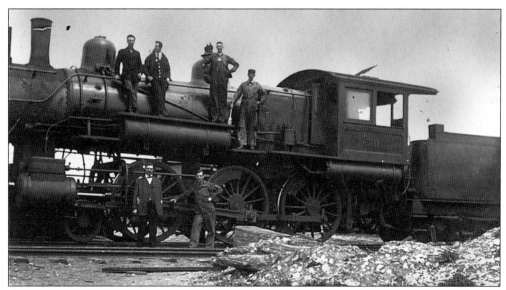

THE RAILROAD. Perhaps without the introduction of the railroad and engines like this one from the late 1800s, Crisfield would not have become the seafood capital on which its reputation has been built over the years. Shortly after the Civil War, marshland was built up with oyster shells to provide track beds, carrying trains to Crisfield Harbor, where they could be easily loaded with the day's catch. So influential was the railroad, the town was named in the honor of the man who helped develop the land that made it possible, John W. Crisfield, shortly after the first trains began chugging into the area.

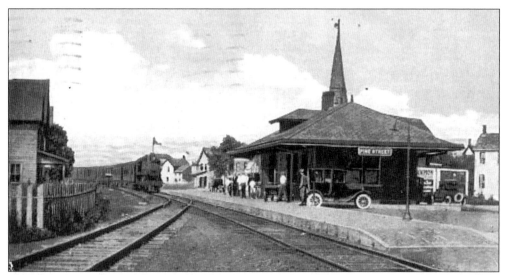

NYP&N RAILROAD STATION. Crisfield's New York, Pennsylvania and Norfolk passenger station opened on Pine Street in 1922, following a movement by the citizens of Crisfield and the local newspaper, the *Crisfield Times*, to bring a decent passenger station to the city. The station included a lounge area for railroad personnel, an heated indoor waiting area for passengers, and public restrooms. After outliving its usefulness as a railroad station, the building was transformed into several businesses, including a drive-in restaurant, before being demolished in the mid-1950s. (Courtesy of Bobbi Jean Mister.)

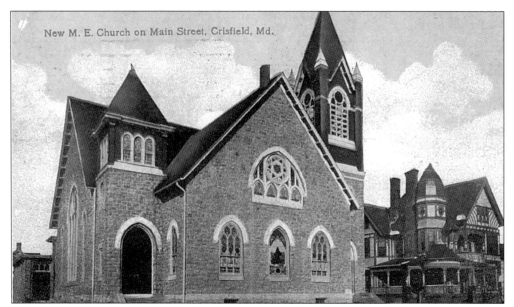

New M. E. Church on Main Street, Crisfield, Md.

IMMANUEL M.E. CHURCH. This church was organized in 1863 as a branch of Old St. Peter's Church in Hopewell. In 1880, the church's first building was dedicated at the corner of Pine and Third Streets, known before 1892 as Horsey and Church Streets. In 1909, the church moved to a new building on Main Street, pictured here. Services are still held in this building, under the title Immanuel United Methodist Church.

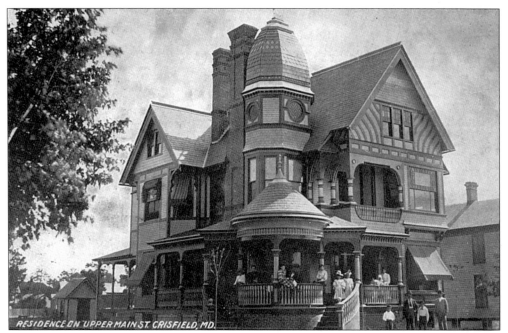

RESIDENCE ON UPPER MAIN ST. CRISFIELD, MD.

RESIDENCE ON UPPER MAIN STREET. One of the more unique and ornate buildings in Crisfield, this residence once stood beside what is now Immanuel United Methodist Church on Main Street, serving as the church's parsonage. Now only existing in photographs and memories, the residence is gone. A church community hall was placed in its location in 1976.

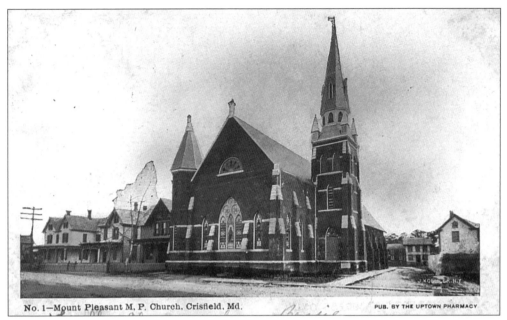

No. 1—Mount Pleasant M. P. Church, Crisfield, Md. PUB. BY THE UPTOWN PHARMACY

MT. PLEASANT METHODIST PROSTESTANT CHURCH. This church was founded in 1876, when the church's first building was constructed at its present location on Main Street. The first building was remodeled into Gleaner's Hall before the building pictured here was constructed at that same location in 1897. Weekly services are still held in the same building, now under the title Mt. Pleasant United Methodist Church.

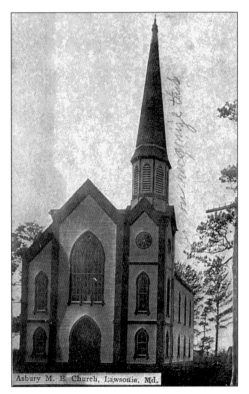

Asbury M. E. Church, Lawsonia, Md.

ASBURY METHODIST EPISCOPAL CHURCH. Constructed in 1880, this building, the fourth to house what is now Asbury United Methodist Church, stood near where the church's cemetery entrance sits on Asbury Avenue today. Fire destroyed this building in 1919, and it was replaced by a granite structure in 1923. The Rev. Thomas Carron first organized the church in 1810. The first service was held that year in the home of Hance Lawson, near Jenkins Creek.

74

First Baptist Church. The first structure housing this church was built on Maryland Avenue in 1890 under the guidance of Rev. John S. Wharton. The congregation moved into a new building, pictured here, at the corner of Somerset Avenue and Main Street Extended in 1922. The church's new home, built under the direction of Rev. Dr. Bob Killgore, cost just under $100,000 to construct. The artist's rendition of the church seen here includes a non-existant ornate garden where Main Street Extended would have been located. (Courtesy of Bobbi Jean Mister.)

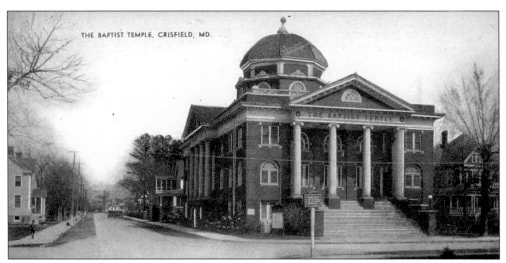

The Baptist Temple. In contrast to the artist's conception of the home of Crisfield's First Baptist Church, this photo postcard of the building, probably taken during the 1940s, shows the location of Main Street Extended. Also interesting in this view is the presence of a street sign in front of the church, directing travelers to Pocomoke, Salisbury, and Lawsonia. Except for the addition of a stoplight and the deletion of the street sign, not much has visibly changed at this intersection since this postcard was printed.

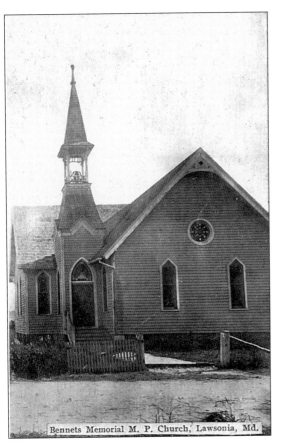

Bennets Memorial M. P. Church, Lawsonia, Md.

BENNETS MEMORIAL METHODIST PROTESTANT CHURCH. Members of Masonic Epitome Chesapeake Lodge 147 Ancient Free and Accepted Masons laid the cornerstone for this church on September 22, 1898. Located in Crisfield's Down Neck section, the building now houses the Wesleyan Church.

ST. JOHN'S EPISCOPAL CHURCH. Located at the corner of Main and Fifth Streets, this church hosted a variety of community events in the 1930s, including a series of popular annual Halloween dances. However, with much of its congregation leaving for military bases and overseas assignments during World War II, the church became a casualty, failing to reopen following the war. (Courtesy of Jessica Anderson.)

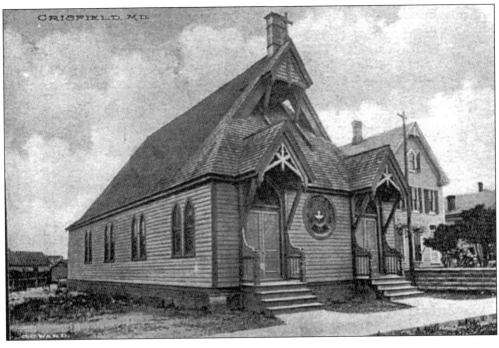

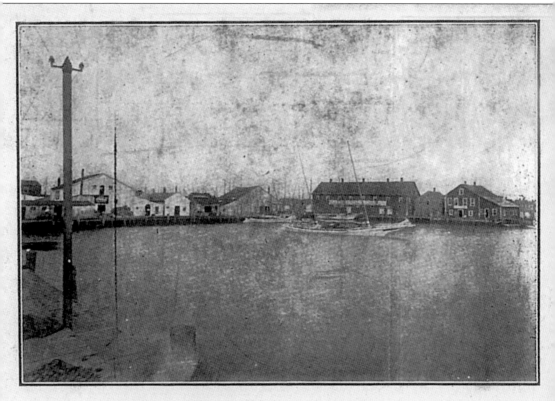

Harbor Scene, Crisfield, Md.

HARBOR SCENE. This is how the area now known as Somers Cove Marina appeared in the years before the marina's construction. While this view was taken during one of the area's more "camera friendly" years, by the 1950s, the area had become run-down, full of abandoned crab shanties and terrapin pens, rotting boat hulls and city garbage. It was during that era that Tidewater Fisheries chairman John P. Tawes sought to restore the area to its former beauty by turning it into a state-of-the-art marina. (Courtesy of Frank Rhodes.)

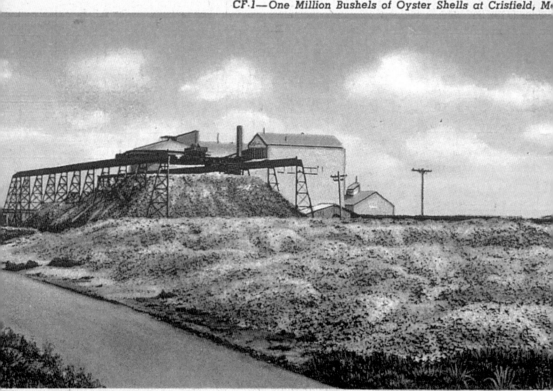

OB·

ONE MILLION BUSHELS OF OYSTER SHELLS. Once oysters were taken out of their shells for packing in Crisfield, most of the shells not being used to build up land were taken to the local lime plant, seen here, to be crushed into lime for use in fertilizer and animal feed. The metal supports visible on the left held a conveyor that carried shells from boats into the factory, where they were processed. After the oyster industry dwindled, there was little use for the lime plant, and it was closed. Stuart Petroleum later used the building as a headquarters for repairing oil barges and similar vessels. The building still stands today.

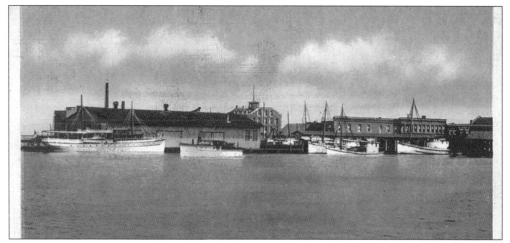

SEA FOOD PACKING HOUSES ON THE WATERFRONT AT JERSEY. One of the most famous clusters of seafood packing and processing businesses in Crisfield once sat on Jersey Island, an area that today consists mostly of state-owned land. Putting this scene into perspective for modern-day viewers, the area to the right is near where the current H. Glenwood Evans & Son Seafood business sits today. The building on the left in this view, behind the schooner, is the L.R. Carson Seafood building. The Carol Dryden Seafood building is located in the center. (Courtesy of Bobbi Jean Mister.)

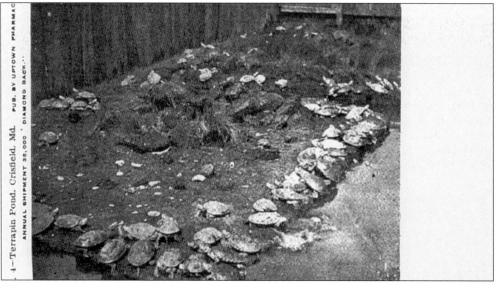

TERRAPIN POND. In Crisfield, the terrapin industry has become nearly synonymous with the name LaVallette. In 1887, Albert LaVallette Jr. concocted an idea to make diamondback terrapin a highly sought delicacy. He copyrighted a recipe for a terrapin-based dish, and then offered the recipe to only one restaurant in each of several large Eastern U.S. cities. Terrapin were abundant in Crisfield at the time, allowing LaVallette to obtain the main ingredient very inexpensively, and then sell it at a high mark-up to the restaurants using his recipe. Though the idea made LaVallette a wealthy man, it exhausted Crisfield's terrapin supply, and by 1912, the area's terrapin population was nearly non-existent, a sharp contrast to the 25,000 annual shipments boasted on this postcard. (Courtesy of Bobbi Jean Mister.)

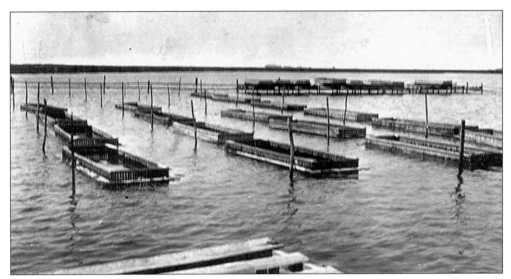

CRAB FLOATS. This view represents an old-fashioned "crab pound," so called because the crab floats were tied to offshore stakes and impounded by a breakwater. Watermen "fishing up," or collecting crabs from the floats, would shove boats out to the pound to gain access. Today, many crab floats are placed close enough to land or docks to allow watermen to simply walk up to them when fishing up. Either way, the crab float remains a popular crustacean-catching device in Crisfield.

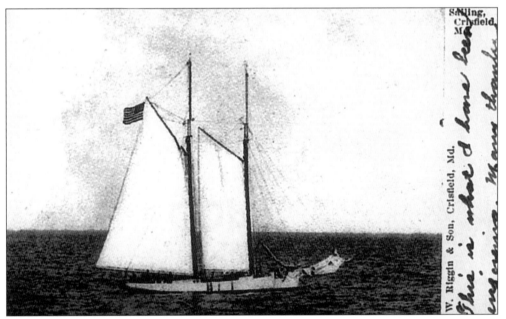

J.W. RIGGIN & SON. The view of this early buy boat, based in Crisfield, helps show how business was conducted during the early part of the 20th century. The boat has its flag raised, the traditional signal that a buy boat was purchasing oysters. Tongers would pull their smaller boats up to anchored buy boats to unload their catches and receive payment. Upon reaching their capacity, buy boats would lower their flags, hoist their anchors, and return to port, where local seafood company representatives would be anxiously waiting. (Courtesy of Frank Rhodes.)

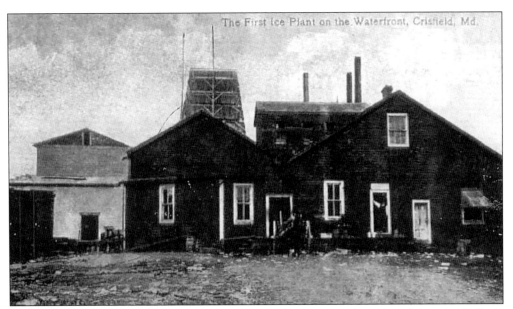

FIRST ICE PLANT ON THE WATERFRONT. Crisfield's first ice plant, seen here, was built in 1872, primarily as an electrical plant to provide electricity for the city's streetlights. While the electricity was produced onsite, the ice was imported from Maine. The business was originally owned and operated by a Mr. Hemmingway. By 1900, the business was no more, and the Crisfield Ice Manufacturing Co. took over as the city's electricity and ice provider. (Courtesy of Bobbi Jean Mister.)

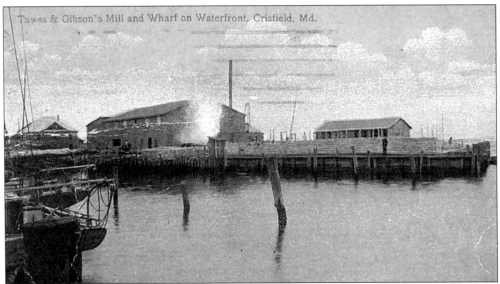

TAWES & GIBSON'S MILL AND WHARF ON WATERFRONT. Though this early Crisfield lumber mill is often associated with the A.B. Cochrane Lumber Co., which began business in Crisfield in 1908, it was most likely a separate operation, possibly even competing with A.B. Cochrane. As noted by the mixture of smoke and sawdust being emitted from the building and the amount of lumber on the wharf in this view, the mill was once a very productive business on Crisfield's waterfront.

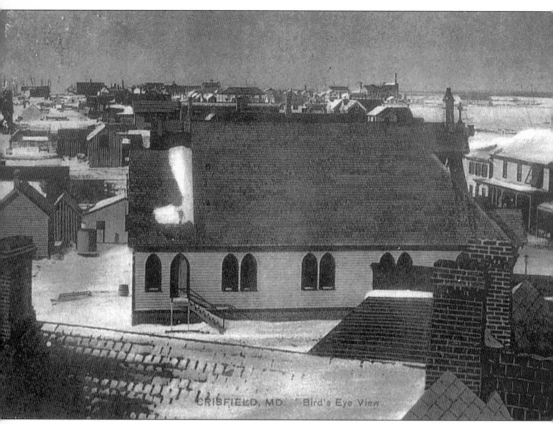

BIRD'S-EYE VIEW. This view, taken from the fourth story of the Odd Fellows Hall at Main and Fourth Streets around 1885, shows the side view of St. John's Church on Fifth Street, along with a number of other buildings present in Crisfield's downtown area during that time. The region in the upper right-hand corner represents Crisfield's waterfront near Tenth Street, frozen over due to temperatures that left the ground on the mainland covered with snow. (Courtesy of Jessica Anderson.)

3469 — Main St., looking East, Crisfield, Md.

MAIN STREET LOOKING EAST. This view of Crisfield, dating from the late 1800s, shows what the city looked like at that time from the fourth story of the Odd Fellows Hall at the corner of Main and Fourth Streets. Prominent buildings in this view include the O.L. Mitchell dry goods store—which also sold notions, boots, and shoes—to the far left and Dr. Ward's Drug Store to the far right. The steeple of Immanuel Church, as it stood on Pine Street, can be seen in the distance. Other buildings in this view include homes owned by Charlie Daugherty, Bill Landon, J.P. Tawes, Harvey Reese, and Dr. Will Colbourn.

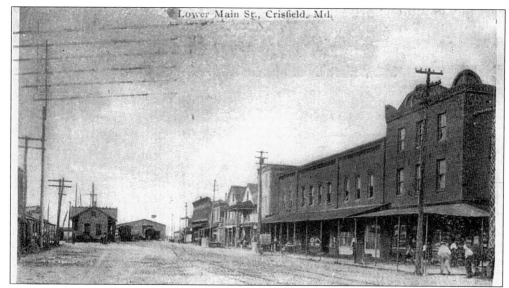

LOWER MAIN STREET. This view of Crisfield's uptown area was taken around 1912, looking toward the waterfront. The building with the peaked roof in the background toward the left was the steamboat wharf, which was later to become the Crisfield City Dock. The square building at the left, at one time the Railway Express Agency, is situated where Captain's Galley Restaurant is now located. Most if not all the buildings in this portion of town were burned in what has become known as the Downtown Fire of 1883, during which the city's only recourse against the blaze was a long-reaching and unsuccessful bucket brigade. Construction following the fire resulted in the first brick and concrete structures ever built within the city limits. (Courtesy of Jessica Anderson.)

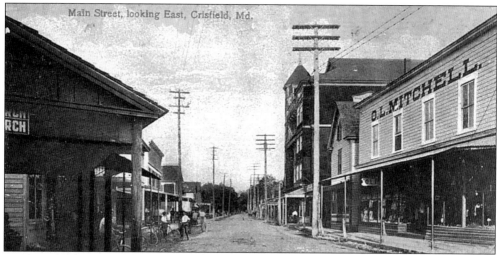

MAIN STREET LOOKING EAST. A number of turn-of-the-century businesses appear in this *c.* 1900 photograph. The building at the far left is the second home of O.L. Mitchell Dry Goods, which had originally been located three doors down on the other side of the street. Beside the O.L. Mitchell building stands Will Sterling's Soft Drinks Store, then the Odd Fellows Temple. Blades' Bicycle Shop was located on the other side of the street, where several residents have their bicycles parked. (Courtesy of James Jackson.)

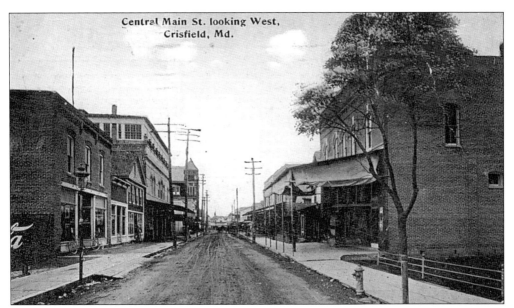

CENTRAL MAIN STREET LOOKING WEST. Early street lamps, seen in this early 1900s postcard, were powered by electricity from the nearby Crisfield Ice Manufacturing Co. The building at the far left, sporting the partial Coca-Cola sign, was the headquarters of W.E. Ward & Bro. Wholesale Grocers. Besides bottling their own soft drinks, owners W.E. and Frederick Ward were local distributors of Coca-Cola, Fowler's Ginger Ale, Hershey chocolates and chewing gum, Quaker City chocolates, and J&W Lang's Cakes.

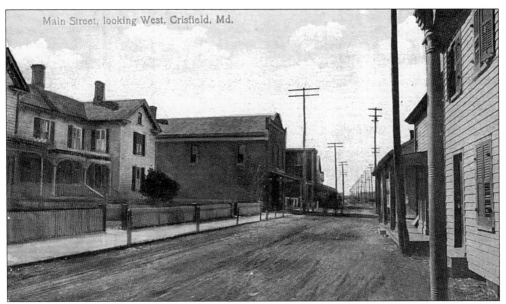

MAIN STREET LOOKING WEST. Some of the finest—and not so fine—buildings in Crisfield appeared along Main Street shortly after the introduction of the railroad to the area. The buildings, seen here sometime in the late 1800s to early 1900s, appear to have been some of the former. Those looking closely may see wheel tracks in the dirt roads that proved sufficient for travel until paved roads were introduced to the city in 1912. (Courtesy of James Jackson.)

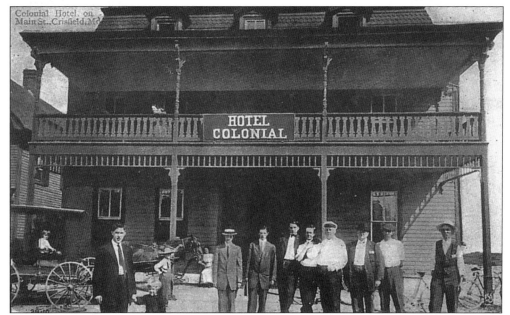

COLONIAL HOTEL. Businessman Joseph Disharoon built the Crisfield Hotel on the city's Main Street in the late 1800s. One of the city's finest showplaces, the hotel was originally managed by Disharoon's brother Lawrence. For reasons unknown today, the hotel's name was changed to the Colonial Hotel in the early to mid-1910s. Lawrence Disharoon became the hotel's owner in 1915. Following Lawrence's death in 1933, Somerset Hotel owner James Byrd bought the Colonial Hotel and changed its name back to the Crisfield Hotel. (Courtesy of Bobbi Jean Mister.)

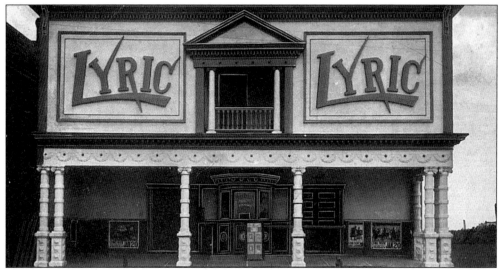

NEW LYRIC THEATRE. The Lyric Theatre was the "place to be" in downtown Crisfield when this postcard was printed in the early 1900s. Located at the corner of Main and Fifth Streets, the theater initially showed only silent films before moving to "talkies," predominately westerns, once the technology made its way to Crisfield. The theater became a casualty of the Great Crisfield Fire in 1928, located only two doors down from the fire's origin at the competing Arcade Theatre. Admission was 25¢ for adults at the time of the Lyric's demise.

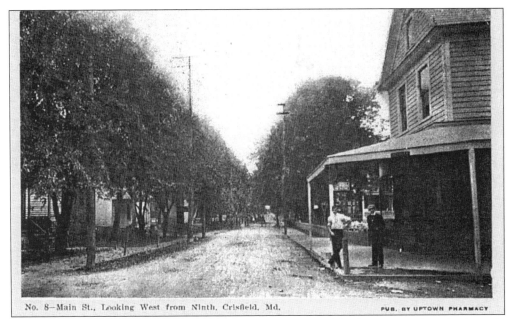

No. 8—Main St., Looking West from Ninth, Crisfield, Md.

PUB. BY UPTOWN PHARMACY

MAIN STREET LOOKING WEST FROM NINTH. Corner stores, like the one seen here in the early 1900s, once dotted Crisfield's landscape, providing goods in residential sections of the city. These stores were important community landmarks, especially for those who did not have readily available transportation to the city's main business district. (Courtesy of Bobbi Jean Mister.)

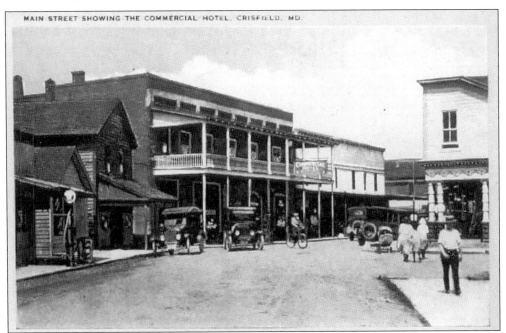

MAIN STREET SHOWING THE COMMERCIAL HOTEL. CRISFIELD, MD.

MAIN STREET SHOWING THE COMMERCIAL HOTEL. Crisfield had progressed into the age of automobiles when this postcard of Main Street and Fifth Street was printed, probably in the late 1920s. Strip stores now stand where the hotel sits in this view. The building beside the hotel on the right sits on what is now the site of the Crisfield Post Office. (Courtesy of Bobbi Jean Mister.)

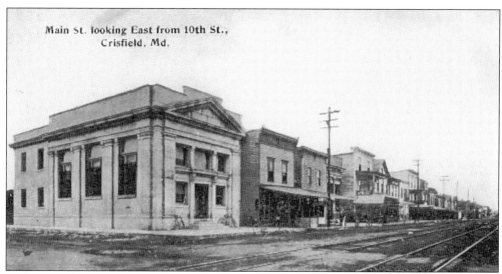

Main St. looking East from 10th St., Crisfield, Md.

MAIN STREET LOOKING EAST FROM TENTH STREET. The Bank of Crisfield building, visible on the far left, stands out in this early 1900s postcard, which also shows the railroad tracks that extended all the way down to Crisfield's waterfront, just out of this view's range. The bank building was constructed with the organization of the Bank of Crisfield by Clarence Hodson in 1893. The bank operated independently until 1973, when it merged with Citizens National Bank to become Eastern Shore National Bank. That bank was later bought by Peninsula Bank, which took the bank out of the building in the mid-1990s. (Courtesy of Bobbi Jean Mister.)

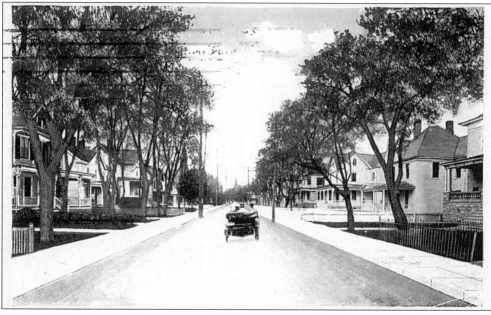

CENTRAL MAIN STREET. The occupants of this motor car may have been on a Sunday drive when they chanced to appear on this postcard not long after the first streets in the city were paved in 1912. Paving on the first streets extended from Main Street to Ninth Street. However, progress did not come at such a fast clip in those days. Most of the city's street remained unpaved until the mid- to late 1920s.

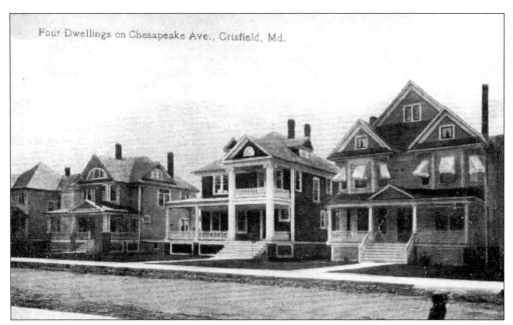

Four Dwellings on Chesapeake Ave., Crisfield, Md.

FOUR DWELLINGS ON CHESAPEAKE AVENUE. This quartet of homes lined Chesapeake Avenue when this postcard was printed, sometime before the street was paved in 1927. Though the road remains predominately residential, a lone business, Riggin's Market, exists there today, as it has for more than 50 years. (Courtesy of Bobbi Jean Mister.)

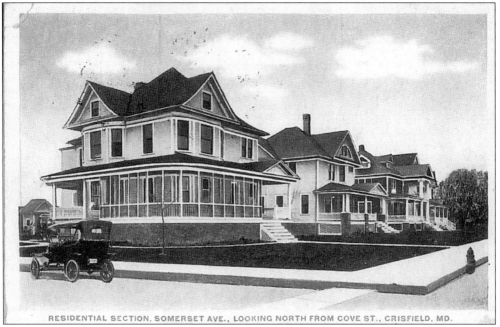

RESIDENTIAL SECTION, SOMERSET AVE., LOOKING NORTH FROM COVE ST., CRISFIELD, MD.

SOMERSET AVENUE LOOKING NORTH FROM COVE STREET. An early Ford parked beside these dwellings on Chesapeake Avenue dates this view to the 1920s or 1930s. Still a residential section today, Somerset Avenue still boasts some of the city's most beautiful homes. (Courtesy of Bobbi Jean Mister.)

MARYLAND AVENUE. Residential buildings, trees, and fences were the scene for this early postcard view. Businesses have since joined the residences on this street for a 21st century co-existence. Today, Maryland Avenue is part of Crisfield's dual-highway system, along with Richardson Avenue and West Main Street. (Courtesy of Jessica Anderson.)

ASBURY AVENUE. Homes, trees, and telephone poles lined this portion of Asbury Avenue when this postcard was printed in the late 1800s. Much of the same can still be found on the street today.

Twelfth Street, Crisfield, Md.

SOMERSET AVENUE. This postcard is titled "Twelfth Street," but the name is obviously a mistake. Though a Twelfth Street has existed in Crisfield since 1892, it has been located at the end of town opposite where this early 1900s view of Somerset Avenue was captured. One of the city's most prominent features, its standpipe, can be seen in this view. Built in conjunction with Crisfield's first citywide water system in 1895, the standpipe served its purpose of providing water for the city until a new water tower went into service in 1984.

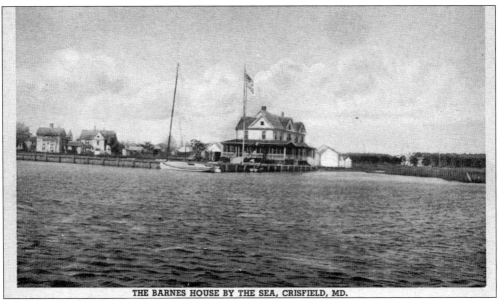

THE BARNES HOUSE BY THE SEA, CRISFIELD, MD.

THE BARNES HOUSE BY THE SEA. One of Crisfield's picturesque private residences, the Barnes House served for many years as a tourist home and boarding house. Its placement on Crisfield's waterfront has made it the focus of several postcards over the years. (Courtesy of James Jackson.)

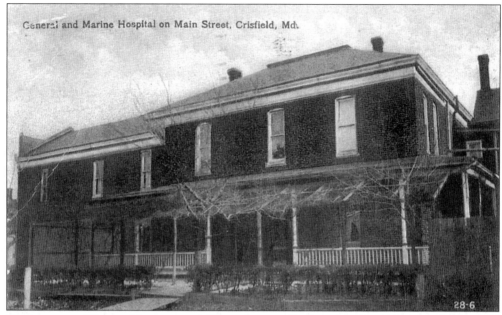

GENERAL AND MARINE HOSPITAL ON MAIN STREET. Dedicated on June 30, 1909, the Crisfield General and Marine Hospital was located in the 1898 brick building at Main Street and Sixth Street that had formerly housed Oliver Gibson's store. Though funding to pay off the debts for interior construction at the building was difficult to come by, local residents chipped in, and in 1910, the 26-bed hospital officially opened with 10 doctors and 10 nurses. The facility offered an operating room and a nursing school and had the ability to carry as many as 40 beds if necessary. The hospital remained open until 1923, when it was replaced by Edward W. McCready Memorial Hospital. (Courtesy of Jessica Anderson.)

GENERAL AND MARINE HOSPITAL. Three of the hospital's nurses posed in front of the facility for this postcard, printed not long after the hospital's opening. (Courtesy of Jessica Anderson.)

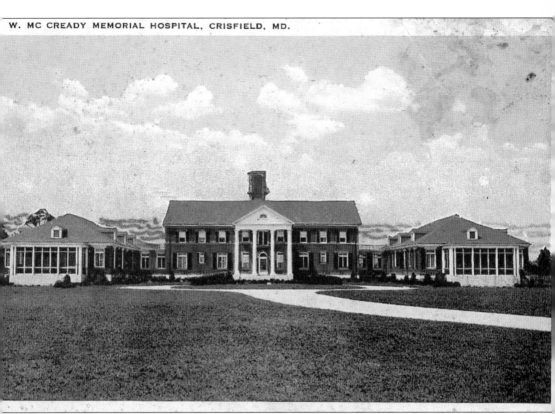

EDWARD W. MCCREADY MEMORIAL HOSPITAL. The story behind Crisfield's modern-day hospital begins with a tragedy. On September 13, 1919, Crisfield native and wealthy cork industrialist Edward W. McCready, his eight-year-old daughter Susanne, and Susanne's nurse Henrietta Steinback were traveling to their home in Chicago when they were killed in an automobile-train collision in Westover. Susanne and the bodies of her father and nurse, who had died instantly, were taken to the Crisfield General and Marine Hospital, where Susanne died on the operating table. When local funeral director I. Samuel Lawson found he had no way of retaining the bodies while funeral arrangements could be made, hospital superintendent Florence Smith offered to keep the bodies in the hospital's reception room until they were cremated and sent to Chicago. Smith also offered McCready's wife a room upon her arrival from Atlantic City, where she had been waiting to meet her husband and daughter. Several weeks later, Mrs. McCready returned to Crisfield to pay her bill. Upon finding the hospital would not charge her for their special services, Mrs. McCready vowed to pay back the hospital and the citizens of Crisfield by constructing a new, state-of-the-art hospital in the city. The facility was constructed at the site of the McCreadys' former home in Crisfield at the cost of $200,000 and dedicated in May 1923. The Alice B. Tawes Nursing Home was added in 1967. The hospital itself was upgraded and expanded in 1980 and added new services and outpatient centers around the Lower Eastern Shore in the late 1990s.

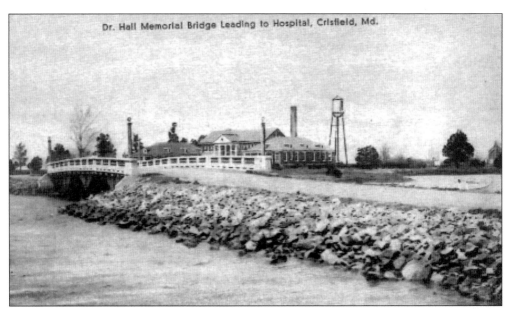

DR. HALL MEMORIAL BRIDGE LEADING TO HOSPITAL. Dedicated on December 17, 1922, this bridge was constructed to provide access from the mainland to Edward W. McCready Memorial Hospital. The bridge was dedicated to the late Dr. Willard F. Hall as "a lasting monument to his usefulness in this community," Crisfield mayor Charles Ward proclaimed during a dedication ceremony. The bridge remains in use today. (Courtesy of Bobbi Jean Mister.)

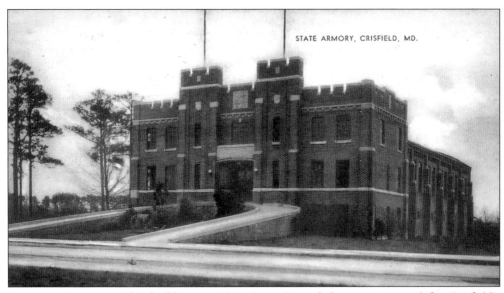

CRISFIELD ARMORY. This building on Main Street Extended was constructed for Crisfield's Maryland State Guard Unit, Co. L, 115th Infantry Regiment, 29th Division in 1926. Co. L was organized in 1914. In 1968, the company was reorganized into the 1229th Transportation Co. When the 1229th was deactivated for a short period in the 1990s, the 121st Combat Mechanized Engineers called the armory home until the 1229th returned. The armory was renamed the Gen. Maurice D. Tawes Armory in 1983 in honor of Crisfield resident and retired guard member Maurice "Dana" Tawes.

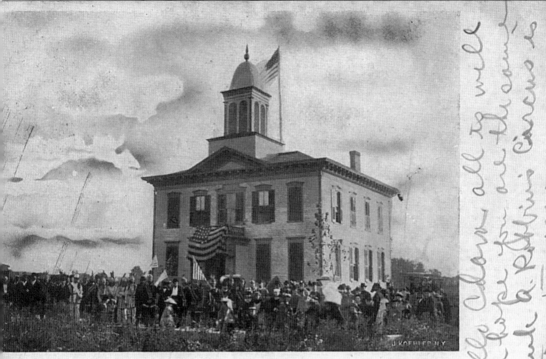

igh School (Arbor Day), Crisfield, Md.

C. E. COLLINS, PUB.

CRISFIELD ACADEMY. Constructed on Asbury Avenue in 1876, the building considered to be the first Crisfield High School was originally known as Crisfield Academy. Tubman Ford served as the school's first principal. The academy was the second high school in Crisfield, Jacksonville High School having been built in 1874. An Arbor Day celebration was occurring when this particular photo was taken at the academy around 1900. Following the construction of the new Crisfield High School in 1908, the academy building was converted into Asbury Elementary School. It served a number of the city's younger students until it was demolished in 1937. H. DeWayne Whittington Primary School stands on the original academy site today.

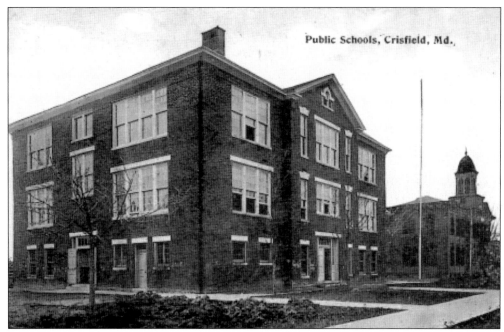

Public Schools, Crisfield, Md.,

CRISFIELD HIGH SCHOOL. The first building to officially carry the name Crisfield High School, pictured above, was constructed on Asbury Avenue in 1908. Used only until 1926, the red brick building was the shortest-lived of all the city's public secondary school buildings. It was replaced after only 18 years due to problems with overcrowding and classroom sizes. A new Crisfield High School, pictured below, featuring a columned front, was built in 1926 to replace the 1908 high school. The 1926 building was located on Somerset Avenue, near where the current high school now stands. Still in use in 1953, following the opening of a more modern high school building on the same site, the 1926 building was destroyed in a fire on February 2, 1972. (Courtesy of Bobbi Jean Mister.)

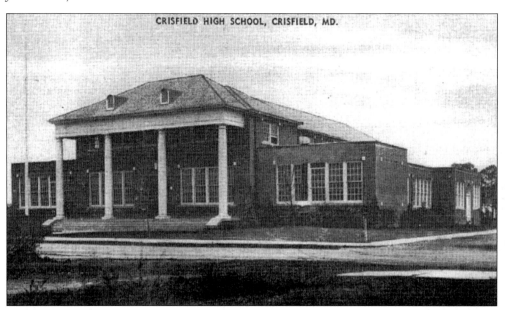

CRISFIELD HIGH SCHOOL, CRISFIELD, MD.

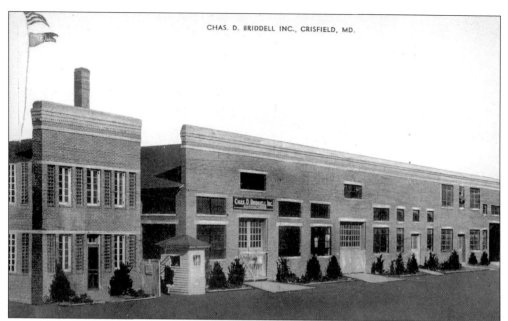

CHAS. D. BRIDDELL INC. The Chas. D. Briddell manufacturing plant, seen here in the 1940s, was for many years one of Crisfield's largest employers. Constructed in 1920, Briddell's Main Street plant received numerous U.S. government contracts during World War II, including at least one for the manufacture of bazooka shells. The plant also turned out seafood and ice tools and cutlery items. In 1946, employee Paul Culver designed a fine-bladed letter opener that would soon become the design of the world-famous Carvel Hall steak knife. Employees manufactured that knife at this plant until it was destroyed in a fire March 3, 1951. Production resumed in smaller, temporary plants a little more than a month later. Following the fire, Briddell's opened in a new, state-of-the-art factory, pictured below, in 1953. The new facility cost approximately $1 million. Production of the Carvel Hall steak knife continued there, as did the manufacture of many other cutlery types and even a series of U.S. Mail scooters. Facing financial difficulties, the Briddell family sold the plant to Towle Silver Co. in 1960, shortly after which the plant was renamed Carvel Hall. Following more financial difficulties, a team of Carvel Hall employees and financiers took control of the company in the early 1990s, under the title CH International. The company is currently owned by Syratech Corporation, which bought Carvel Hall in 1998.

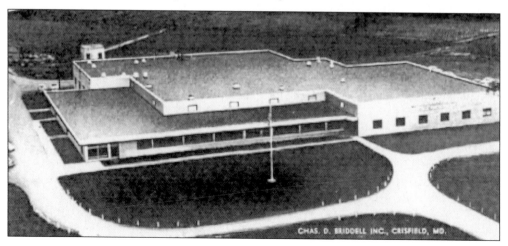

CHAS. D. BRIDDELL INC., CRISFIELD, MD.

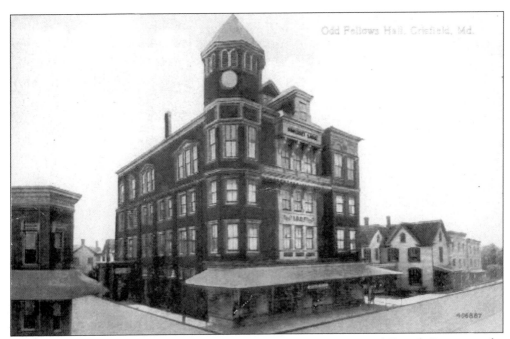

ODD FELLOWS HALL. Crisfield's Odd Fellows Hall at Main Street and Fourth Street was the largest in Maryland. Constructed in the late 1800s, with the founding of Crisfield's chapter of the Odd Fellows fraternal organization in 1892, the building served as the Odd Fellows' lodge hall until financial difficulties and decreased membership caused the organization to disband in the late 1910s. During its peak, Crisfield's Odd Fellows chapter had boasted a membership of several hundred. (Courtesy of Bobbi Jean Mister.)

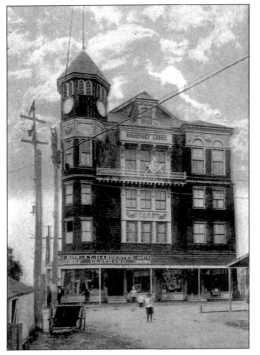

CRISFIELD OPERA HOUSE. Following the de-chartering of Crisfield's Odd Fellows organization, Odd Fellows Hall became a place of commerce, known as the Crisfield Opera House. The building included such businesses as A.L. Hardester Clothes and the Arcade Theatre, as well as serving as headquarters for Masonic Epitome Chesapeake Lodge 147 Ancient Free and Accepted Masons, as noted by the Masonic symbol adorning the front of the fourth story. It was in this building that the Great Crisfield Fire, one of Crisfield's most devastating, started on March 29, 1928. (Courtesy of Frank Rhodes.)

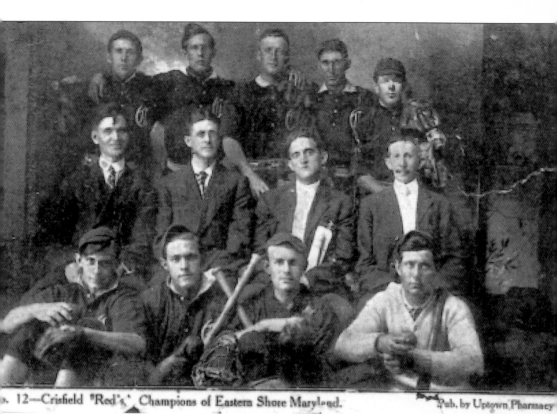

12—Crisfield "Red's," Champions of Eastern Shore Maryland. Pub. by Uptown Pharmacy

CRISFIELD REDS, CHAMPIONS OF EASTERN SHORE MARYLAND. Crisfield's first organized baseball team, the Reds, continued the city's baseball tradition into the 20th century. The team was organized in 1911, nearly 20 years after the city's first official team in 1892. The Reds played at Riggin Field, just off what is now Maryland Avenue. Pictured here are, from left to right, (front row) John Woodland, Raymond Woodland, W. Edwin "Ted" Riggin, and Clarence Howard; (middle row) Brevoort Thawley, H.L. Loreman, Eugene Miles, and Dr. C.E. Collins, who helped bring the team together; (back row) Dyke Sterling, Lownie Tawes, Carl Hoffman, William Holland, and Charles Bradshaw. (Courtesy of Mary Anne Ward.)

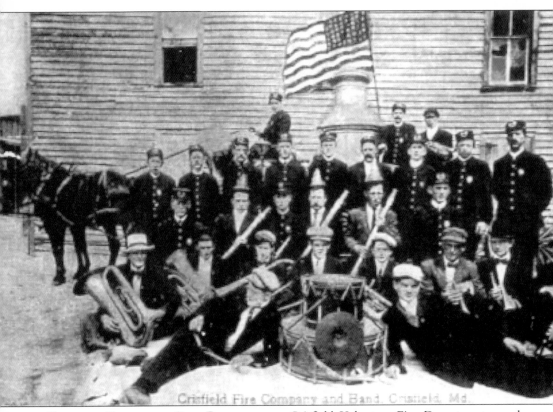

Crisfield Fire Company and Band, Crisfield, Md.

CRISFIELD VOLUNTEER FIRE DEPARTMENT. Crisfield Volunteer Fire Department members posed with band members in this group photo-turned-postcard, taken sometime between 1900 and 1911. At that time, the department's famed 1885 Clapp and Jones horse-drawn steam pumper was stored at Andrew Poleyette's livery stable, shown here. Though not all the men in the photograph have been identified, the picture does include long-ago Crisfielders B. Horace Ford, Jim Ailsworth, Tobe Stevenson, Rupert Somers, Will Poleyette, Sherman Dize, Lum Betts, George "Dickey" Davis, William "Leaguer" Holland, David Whittington, and George "Teagle" Wessells. (Courtesy of Bobbi Jean Mister.)

Eight

CRISFIELD

1928 TO 2001

On March 29, 1928, a fire began inside the Arcade Theatre, located in the Crisfield Opera House at the intersection of Main and Fourth Streets, during the showing of the Greta Garbo film Love. Within a short time, the fire burned through the building's exterior, where it was fanned by heavy winds. Local firefighters could not control the blaze, which destroyed main telephone, telegraph, and power lines. City officials drove 18 miles to Westover to call for help from other area fire departments. The city's water supply was exhausted as firefighters from as far away as Seaford, Delaware, tried to calm the inferno. Water was pumped and transported in from Cove Landing, one-third of a mile away. By the time the fire was out, it had completely destroyed 90 buildings and damaged numerous others. Sixty families were homeless, 300 employees were suddenly jobless, and one person, a Crisfield resident named Frank Morgan, had been killed, struck by debris from a falling building. However, city officials remained optimistic following what some say was the worst tragedy in Crisfield's history. Shortly after the fire was out, they adopted the slogan "Build for the Future." And build, they did.

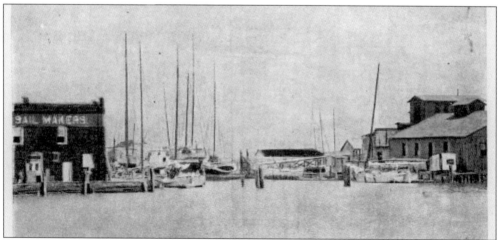

THE SHIP YARD. This 1930s view of Crisfield's waterfront is full of history long gone from the area. The building at the left housed two businesses, the Sail Loft, owned by Alton Pruitt, in the top story, and Edward Plitt's oyster house on the bottom floor. Based in Chicago, Plitt owned several other oyster houses on the Eastern Shore, including one in Chincoteague, Virginia, and one in Oyster, Virginia. The skipjacks in the center are customers at the Jersey Railway, likely awaiting repair. The building to the far left is Christy's oyster house, which was severely damaged in a fire during the early years of World War II. (Courtesy of Bobbi Jean Mister.)

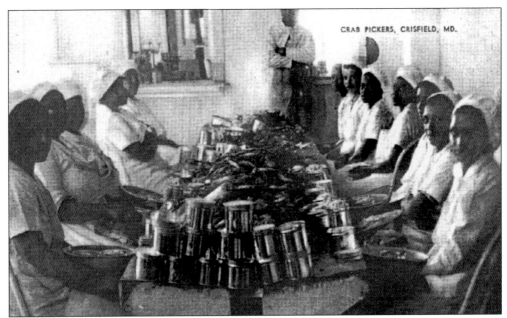

CRAB PICKERS. This 1930 view of crab pickers could have been taken from nearly any of the dozens of seafood companies that operated in Crisfield at that time. From the tools to the procedure to the "uniform," seemingly not much has changed in the picking industry since this view was printed. (Courtesy of Bobbi Jean Mister.)

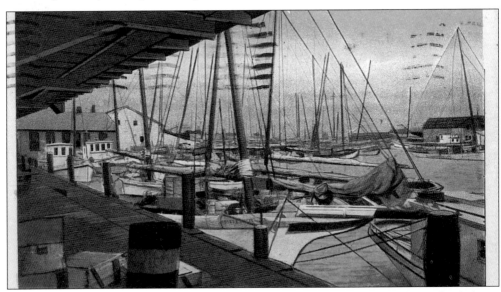

WHARF AND HARBOR. This *c.* 1930 view, looking out from Crisfield's steamboat wharf, shows some of the hundreds of boats, including skipjacks, powerboats, and buy boats, that once flocked to Crisfield on a daily basis. Of particular note are the crafts known as "run boats," so called because they would buy seafood from Maryland's Western Shore and other points, then "run 'em in" to Crisfield for several seafood dealers, most notably John T. Handy Co. The old Railway Express Agency office can be seen to the left of this view, while a small portion of Jersey Island can be seen to the far right.

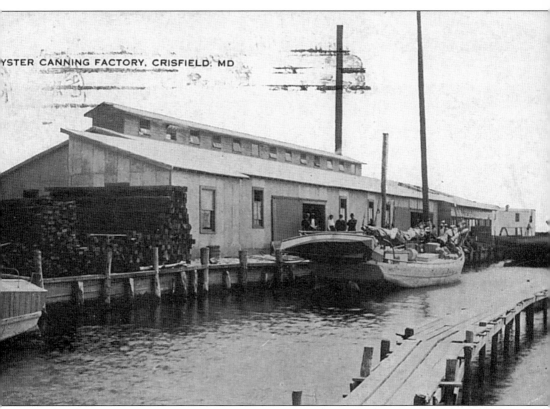

OYSTER CANNING FACTORY, CRISFIELD, MD

OYSTER CANNING FACTORY. This factory, thought to be located in Crisfield's Hoptown area, is similar to many packing plants found in the Crisfield area in the 1930s and 1940s. Few oyster canneries remain in Crisfield today. However, even with a decline in the industry in the 1920s, oyster canning remained a profitable business in Crisfield through the first half of the 20th century. (Courtesy of James Jackson.)

UNIVERSITY OF MARYLAND SEAFOOD PROCESSING LABORATORY. Established in 1954 in Crisfield's Brick Kiln area, at the Small Boat Harbor, this University of Maryland building was constructed to house research regarding seafood packing and purification. Projects at the lab over the years included developing faster ways to pasteurize seafood, ways to better preserve frozen seafood, and how to make better use of waste products stemming from the production of seafood. No longer in use, the building and surrounding property was put up for sale by the City of Crisfield in 2001.

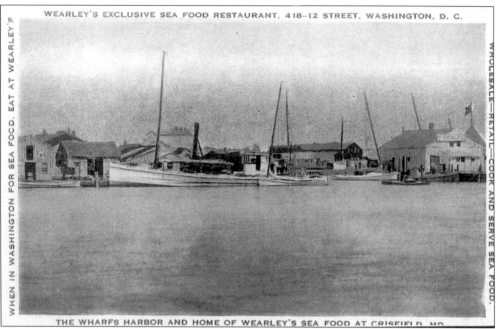

WEARLEY'S EXCLUSIVE SEA FOOD RESTAURANT. So popular was Crisfield's seafood industry at one time, at least one out-of-state eatery, Wearley's Exclusive Sea Food Restaurant, used a scene of Crisfield Harbor in its advertising, with this postcard proclaiming Crisfield as the home of Wearley's seafood. Items such as Crisfield Crab Soup can still be found on the menus of some restaurants in and around Maryland today. (Courtesy of Jessica Anderson.)

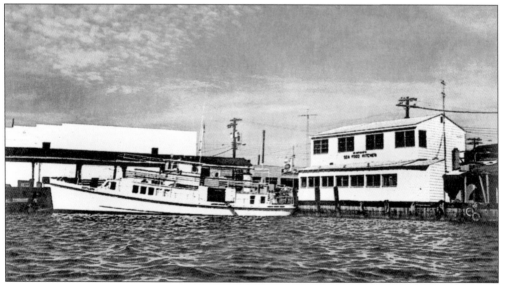

WINDSOR'S SEA FOOD KITCHEN. This 1960s view shows Windsor's Sea Food Kitchen on the waterfront. Established on lower Main Street by Homer and Elma Windsor in 1956, the restaurant moved to the location seen here in 1960, operating until Mr. Windsor's death in 1973. In 1976, it reopened as the Captain's Galley Restaurant and remains in operation under that name today. (Courtesy of Frank Rhodes.)

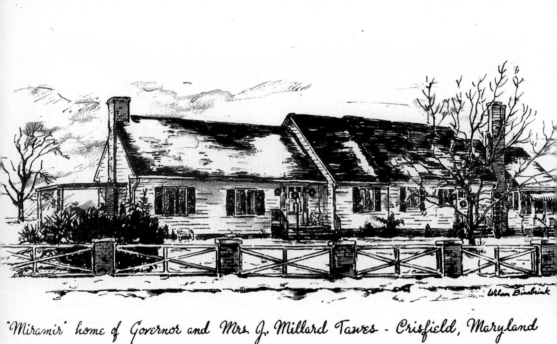

"Miramir" home of Governor and Mrs. J. Millard Tawes - Crisfield, Maryland

MIRAMIR. This home of Gov. J. Millard Tawes and his wife, Avalynne, was constructed on the site of the former Hygeia Beach in Crisfield. Governor Tawes, a Crisfield native and governor of Maryland from 1959 to 1967, held a number of public offices for 41 years, beginning as Somerset County clerk of court in 1930 and ending as director of the Maryland Department of Natural Resources in 1971. Today, the annual J. Millard Tawes Crab and Clam Bake, one of Maryland's preeminent seafood celebrations and political destinations, is held in his honor. (Courtesy of Scorchy Tawes.)

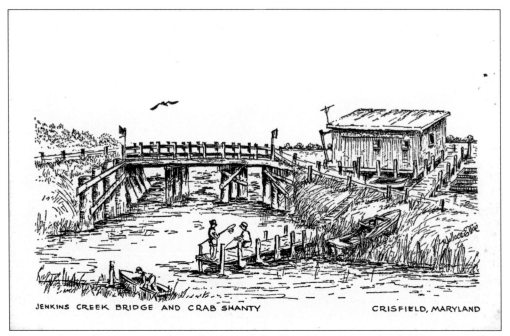

JENKINS CREEK BRIDGE AND CRAB SHANTY · CRISFIELD, MARYLAND

JENKINS CREEK BRIDGE AND CRAB SHANTY. A familiar sight to many Crisfield boaters, Jenkins Creek was once surrounded by a number of crab shanties. The artwork printed on this postcard was drawn by Crisfield artist Wallace E. Dize. (Courtesy of James Jackson.)

Crisfield, Maryland

JERSEY ISLAND BRIDGE. This sketch shows two pieces of Crisfield history: the Jersey Island Drawbridge and the *Maggie Julia*, a log canoe long used by Capt. Wesley Cox. Both the bridge and Captain Cox were one-of-a-kind items belonging to Crisfield. Originally built in 1880, the drawbridge, providing access from the mainland to seafood houses at Jersey Island, rolled backward on a track to provide access to vessels instead of raising up like most drawbridges. It was demolished in 1961 to make way for the entrance to Somers Cove Marina.

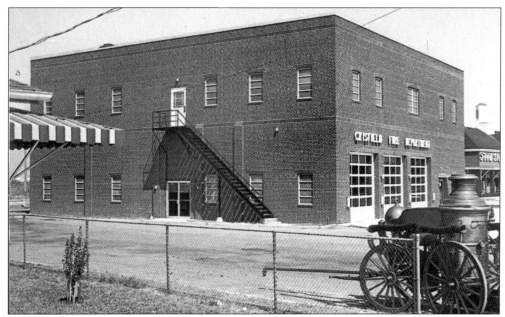

CRISFIELD FIRE DEPARTMENT. Crisfield's current fire hall was dedicated in 1961 to replace the city's former fire hall on Broadway. The Broadway fire hall was used for a variety of purposes, including city storage, and was the headquarters of the Somerset Animal Welfare Society's animal shelter before being demolished in 1998. The current fire hall, located at the beginning of West Main Street, was constructed at a cost of $120,000. The A&P Food Store beside the hall, as seen in this 1960s view, is today a Meatland grocery store. Meatland moved into that building in 1976.

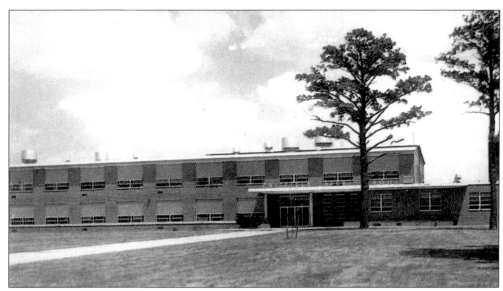

CRISFIELD HIGH SCHOOL. School officials modernized Crisfield's high school in 1953, with the construction of a more modern high school building. Following the 1972 fire, which damaged part of the 1953 building, a new Crisfield High School was built, incorporating part of the 1953 school with a more modern design. The 1972 school was renovated in 1997, with the addition of an elevator and handicap facilities. (Courtesy of Jessica Anderson.)

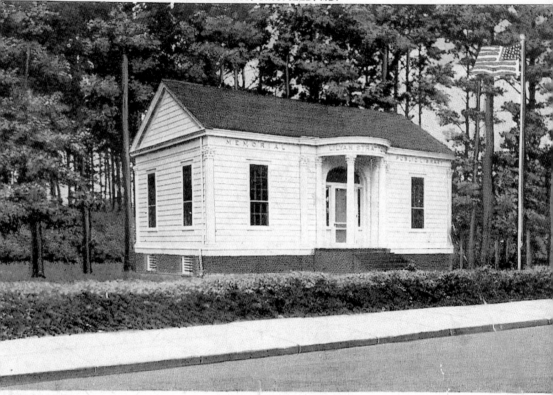

LILYAN STRATTON CORBIN MEMORIAL LIBRARY. Like Crisfield's current hospital, the existence of the city's current museum was brought about by a tragedy. Actress, author, and Crisfield native Lilyan Stratton Corbin had been driving in Parsippanny, New Jersey, near her home, with her niece Blance Lee Hurst of Parksley, Virginia, on November 1, 1928, when Mrs. Corbin's scarf blew up over her face, causing her to lose control of the vehicle. Both died in the ensuing accident. Following her death, Mrs. Corbin's husband, Alfred, had arranged to have a mausoleum built for his wife's cremated remains in Crisfield on the site of the current Carter G. Woodson Middle School. While making arrangements to have the mausoleum built, Mr. Corbin began to take an interest in the city's library, then located in a Main Street house, as it had been since leaving its original location in a storeroom in the William Gibson building on central Main Street in 1925. Upon learning how much having a public library had enhanced the lives of Crisfield's residents, he vowed to build a full-fledged library building as a lasting tribute to his wife. His son John designed the building. It was constructed on Main Street Extended and dedicated in 1930. In 1934, following several years of vandalism and break-ins at Mrs. Corbin's mausoleum, caused in part by rumors of jewels having been kept there, Mr. Corbin moved his wife's remains to the library, where they are today. The land on which the mausoleum sat was donated to Somerset County for the placement of a school building, and the ornamental fountain that sat there was placed outside the library, where it still remains.

Chesapeake Bay log canoe owned and used by Capt. Wesley R. Cox for oyster tonging and crabbing for over 70 years. Built in 1900. Length 32 feet. Breadth 7 feet. Depth inside hull 2 feet. Originally built with centerboard. Rigged with sails set on a raking, unstayed foremast, mainmast and jib. She was sailed in Tangier Sound, generally with a one man crew.

CHESAPEAKE BAY LOG CANOE. Mounted for display in 1976 as a project by the Crisfield Bicentennial Committee, Capt. Wesley R. Cox's log canoe, the *Maggie Julia*, was used for tonging oysters and crabbing for more than 70 years. Built in 1900, the boat was 32 feet long, 7 feet wide, and 2 feet deep. It was sailed in Tangier Sound.

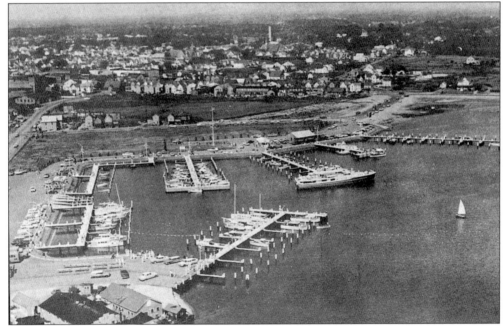

SOMERS COVE MARINA. Constructed cooperatively through the City of Crisfield, Somerset County, and the Maryland Port Authority, Somers Cove Marina was officially dedicated on June 16, 1962. Construction for the 144-slip marina cost $851,000, just over half of the $1.5 million originally projected. Ownership of the facility was split among the city, county, and state for a little more than 20 years until 1983, when the State of Maryland took over full control of the marina.

MASONIC TEMPLE. Crisfield's first fraternal organization, Masonic Lodge, Chesapeake No. 147 Ancient Free and Accepted Masons was founded in 1869. The Masons first met above James Goodsell's oyster house in Goodsell's Alley, and Goodsell was the Crisfield lodge's first master. Following several changes in location, the lodge switched its meeting place to the Gibson Building at the corner of Sixth and Main Streets in 1907, then to the Odd Fellows Hall in 1909, when the Gibson building was transformed into the Crisfield General and Marine Hospital. In 1927, the Masons moved to the building seen in this 1950s view. The building still stands today at the corner of Main Street and Somerset Avenue.

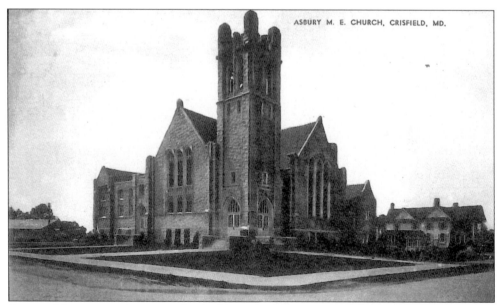

ASBURY METHODIST CHURCH. This building, the fifth to carry the Asbury Church name, was built in 1930 to replace the Asbury Methodist Episcopal Church built in 1923. The 1923 church had been destroyed by fire in 1927. Congregation members dedicated each of the 1930 church's shingles for donations to help fund construction. The church still stands at the corner of Lawsonia Road and Asbury Avenue. (Courtesy of Frank Rhodes.)

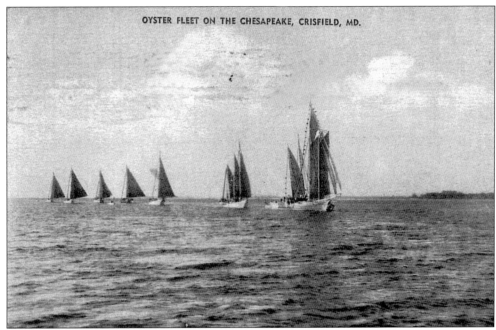

OYSTER FLEET ON THE CHESAPEAKE, CRISFIELD, MD.

OYSTER FLEET. Hauling oysters to help support Crisfield's seafood industry was the goal of this 1930s oyster fleet. Boats pictured, from front to back, include a schooner, a skipjack, a bug eye, and more skipjacks, each one historic in its own right.

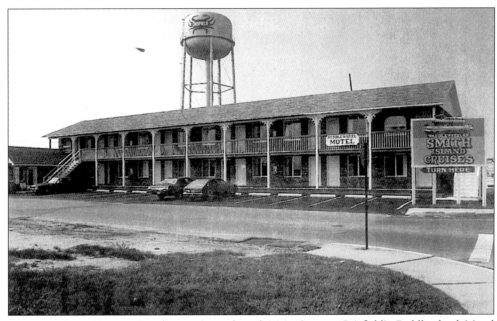

PADDLEWHEEL MOTEL. Standing at Seventh and Main Streets, Crisfield's Paddlewheel Motel serves as lodging for visitors who come to sample the city's seafood, view its waterfront, or just relax for awhile. Crisfield's crab-emblazoned water tower stands in the motel's background, while a sign beside it advertises cruises to Smith Island. (Courtesy of Frank Rhodes.)

UNITED STATES POST OFFICE. The Crisfield Post Office was initially established in Jacksonville on July 16, 1861, under the leadership of postmaster Edward Jackson. Following several changes in location, it was placed in the West Main Street building now housing Clarence Sterling & Son Marine Hardware before moving to its current location, shown here, in 1933. The wing on the right was the home of Crisfield's Customs House until that division was discontinued in 1971. The traffic light, mounted in the middle of the street to the left, would eventually be hung from a wire at that Fourth and Main Street intersection until its removal in 1995.

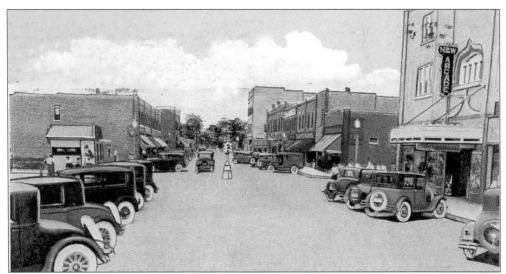

CENTRAL MAIN STREET. Less than a week after the Great Crisfield Fire of 1928, plans began to rebuild Crisfield's uptown section. Businesses operated out of tin shacks while permanent structures were built to replace those charred in the fire. This view shows the area in which the fire originated, shortly after the rebuilding process had begun. The New Arcade Theatre stands to the left in this view, where Odd Fellows Hall had once stood. With the exception of that building, demolished in 1995, and the small stand to the right, every building pictured in this early 1930s postcard remains standing on Crisfield's Main Street today.

113

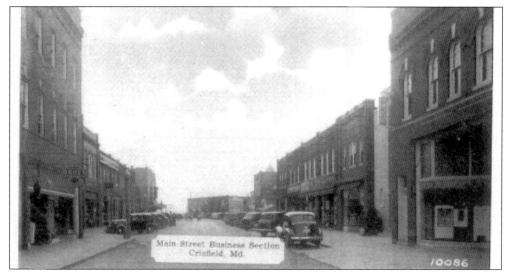

MAIN STREET. The two stores most dominant in this 1930s view, Coffman-Fisher Co. and McCrory's 5 & 10 Store, served Crisfield for a number of years before ultimately leaving the area. Coffman-Fisher opened its Crisfield store in 1929. In 1966, under financial distress, the company sold the store to manager Ferguson Halterman, who operated it for a number of years as Halterman's. McCrory's opened its Crisfield store sometime in the 1910s. The original McCrory's building was destroyed in the 1928 fire but rebuilt in the same location in 1929. It remained at its new building until closing due to financial difficulties in 1995. (Courtesy of Jessica Anderson.)

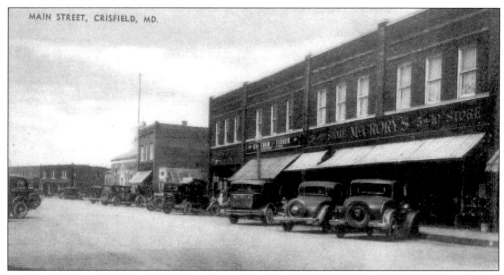

MAIN STREET BUSINESS SECTION. This 1930s view shows the second headquarters of Crisfield Elks Lodge 1044, in the second story of the building to the right. Founded in 1906, the Crisfield Elks had originally met in Odd Fellows Hall until it burned in 1928. In 1943, the Elks purchased a home at Third and Main Streets, remaining at that location until its present home on Maryland Route 413 was constructed in 1960. Other buildings of note in this view include Peyton's Pharmacy, W.T. Grant & Co., and Frank P. Landon's Department Store to the left; the Nora Davis Shop, McCrory's, and Coffman-Fisher Co. on the right; and the Arcade Theatre in the distance at the left. (Courtesy of Jessica Anderson.)

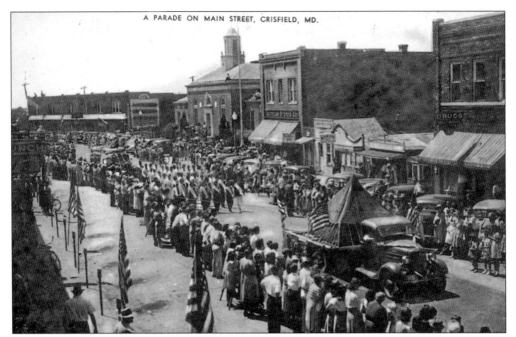

A PARADE ON MAIN STREET, CRISFIELD, MD.

A PARADE ON MAIN STREET. Spectators turned out for this 1930s Labor Day parade, lining the streets to get a good view. Cars are parked at an angle, unlike the parallel parking spaces in that same area today, in front of such businesses as the American Store, located where Carey's Soda Fountain exists today, and Kent Pharmacy, at the far right.

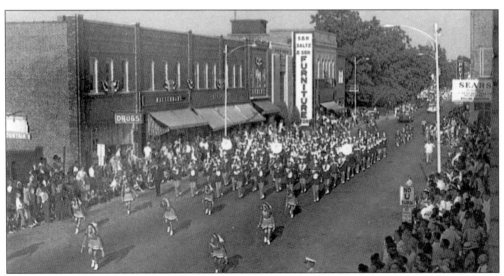

NATIONAL HARD CRAB DERBY PARADE. When the National Hard Crab Derby began in Crisfield in 1948, the entire event consisted of a crab race held in conjunction with the annual Chesapeake Bay Fishing Fair. By the time this photo was taken, *c.* 1969, the Crab Derby had evolved into an annual Labor Day weekend-long event, consisting of a number of contests, a carnival,and a Main Street parade. Here, a high school marching band entertains parade-goers in front of such long-gone Crisfield businesses as Kent Pharmacy, Halterman's , McCrory's, Scher's clothing store, and S&N Saltz & Son Furniture. (Courtesy of Jessica Anderson.)

115

BICENTENNIAL PYRAMID, 100 YEAR TIME CAPSULE, 1976-2016 CRISFIELD, MARYLA

BICENTENNIAL PYRAMID. Crisfield celebrated the American Bicentennial in 1976 with its one-of-a-kind Cheops pyramid time capsule, located near the main office of the Crisfield Housing Authority. Commissioned by the Crisfield Bicentennial Committee, the project received letters of commendation from such dignitaries as President Gerald Ford and Queen Elizabeth II. Constructed by members of the Robert Goldsborough family, the pyramid contains artifacts of local, national, and international importance. The capsule is scheduled to be opened on July 4, 2076, exactly 100 years after it was sealed.

Nine

SCORCHY TAWES

*F*or decades, Crisfield native Norris "Scorchy" Tawes has viewed the Delmarva Peninsula through a lens. Known regionally for his "Delmarva Outdoor Report" and "Scorchy's Corner" segments on WBOC-TV, Tawes has captured Delmarva on film as both a photographer and a television host for decades. Throughout the years, his photographs have appeared in many forms, as newspaper photographs, as illustrations in Readers Digest Books, on promotional material for the National Wildlife Service, on advertising brochures, and on postcards, just to name a few.

Though he is semi-retired today, Scorchy Tawes has become a household name in the Delmarva region and beyond. While postcards based on his photography appear in other sections of this book, this chapter is dedicated solely to his hometown, Crisfield, as seen through the viewfinder of Scorchy Tawes.

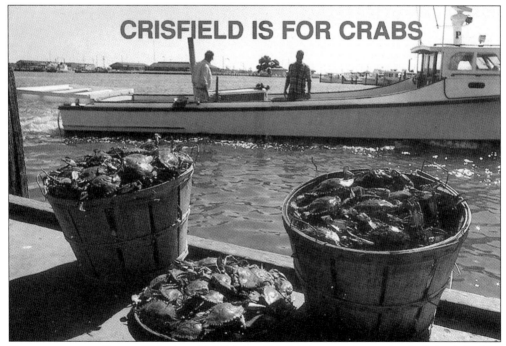

CRISFIELD IS FOR CRABS. This view, highlighting Crisfield's reputation as the Crab Capital of the World, shows a pair of watermen sailing behind bushel baskets full of the city's most well-known delicacies.

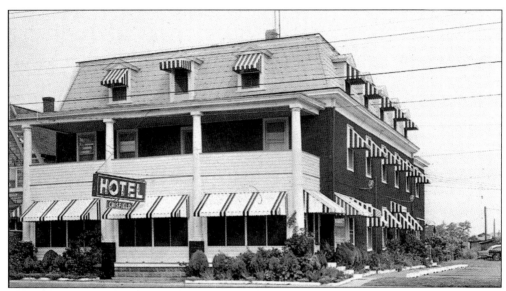

HOTEL CRISFIELD. In the late 1930s or early 1940s, Crisfield Hotel owner James Byrd sold his business to Fred C. Haislip, who, in turn, sold it to Clarence Butler. In 1952, Butler sold the hotel to Charles Crockett. In 1973, Crockett sold the hotel to Alfred Tuttle, who owned the building when it looked like this. Though still standing on West Main Street in Crisfield, few would recognize the current building as the same one in this 1970s view. (Courtesy of Bobbi Jean Mister.)

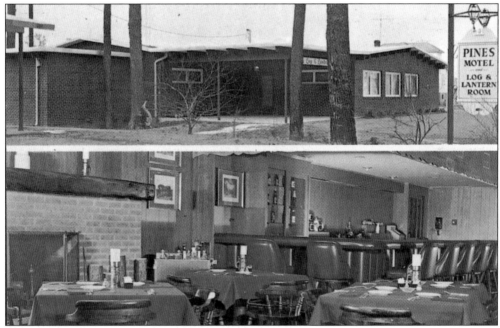

PINES MOTEL RESTAURANT. The Log and Lantern Room served for a number of years as restaurant to the Pines Motel before being closed due to business concerns. In its heyday, the restaurant and bar hosted live entertainment for its patrons and the Crisfield community. Following its closing, the restaurant was used for a period of time as the headquarters of Crisfield's MAC Multi-Service Senior Center.

CAPTAIN'S GALLEY ISLAND TOURS. Known for its backfin Captain's Crabcake, Captain's Galley Restaurant, the top view on this postcard, opened in 1976 at the former location of Windsor's Seafood Kitchen on Crisfield's waterfront. Still in operation today, the restaurant has expanded with a crab deck and a shopping area. The center image on this card depicts the *Dorolena*, the mail boat to Tangier Island. The bottom image shows a sign for Somers Cove Motel, which opened adjacent to Somers Cove Marina in 1979. (Courtesy of Scorchy Tawes.)

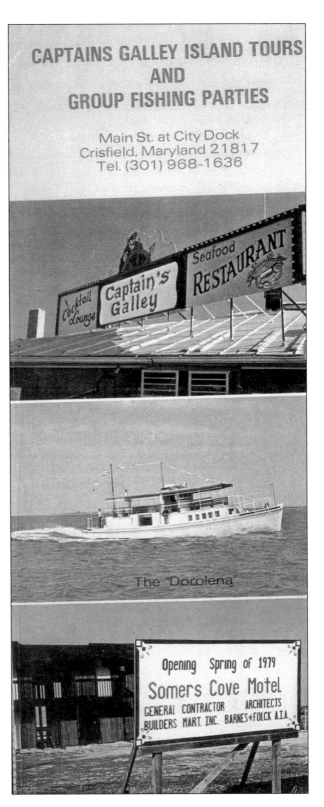

CAPTAINS GALLEY ISLAND TOURS
AND
GROUP FISHING PARTIES

Main St. at City Dock
Crisfield, Maryland 21817
Tel. (301) 968-1636

The "Dorolena"

Opening Spring of 1979
Somers Cove Motel
GENERAL CONTRACTOR ARCHITECTS
BUILDERS MART. INC. BARNES+FOLCK A.I.A.

SOMERS COVE MOTEL. Crisfield's only waterfront hotel sits just outside Somers Cove Marina, next to the U.S. Coast Guard Station, on Norris Drive. Opened in 1979, the motel has lodged a number of visitors for more than two decades.

MILBOURNE'S CRAB MEAT. Founded by Gordon E. Milbourne in the early 1900s, Milbourne Oyster Co. was once one of the most recognizable names in Crisfield seafood. Located on Jersey Island, the company's headquarters turned out thousands of gallons of oysters during the first half of the 20th century, expanding its offerings to crab meat and shrimp in the 1960s and 1970s. No longer in existence, the company remains fondly remembered by a number of Crisfield residents. (Courtesy of Scorchy Tawes.)

THE WARD BROTHERS. Arguably the most famous Crisfield natives in the city's history, Steve Ward (left) and his brother Lem (right) carved some of the most notable decoys ever created. Steve carved his first decoy in 1909; Lem in 1917. The brothers split their early careers between decoy carving and barbering. Word spread of the perfectionism with which their hunting decoys were made, and demand began to outweigh the supply. However, by the time of the Great Depression, the number of wildfowl in the Chesapeake Bay, and subsequently the number of hunters, began to dwindle. This, coupled with developments that began to allow mass production in the decoy industry, influenced the brothers to take their carving in a new direction. Instead of hunting decoys, the Ward Brothers would concentrate on decorative carvings at their Calvary workshop. Steve carved the birds, and Lem painted, sometimes taking months at a time to get their carvings just right. Their Calvary workshop became well known to those in the region. In 1948, they won the National Decoy Contest in New York City, drawing worldwide attention to their art. Twenty years later, the Ward Brothers Foundation was created in Salisbury, Maryland, to provide a lasting tribute to the decoy pioneers and their contemporaries. The brothers continued hand-carving and hand-painting decorative birds until 1970, when a stroke paralyzed Lem's entire right side and Steve began suffering from cataracts. They would never turn out another carving. Lem passed away in 1976. Steve followed in 1984. But even in the 21st century, and all around the world, their names are synonymous with decoys and carvings. This view shows them in their workshop, doing what they did best, in 1970.

THE HARBOR. Sunny skies made for a picturesque view of Crisfield Harbor from the City Dock when this view was printed. The paved area to the far left represents the dock's parking area and beyond that, the end of Crisfield's dual highway, also known as The Strip, a cul-de-sac in, around, and back through the city that was circled time and time again on any given Saturday night by Crisfield teenagers and adults.

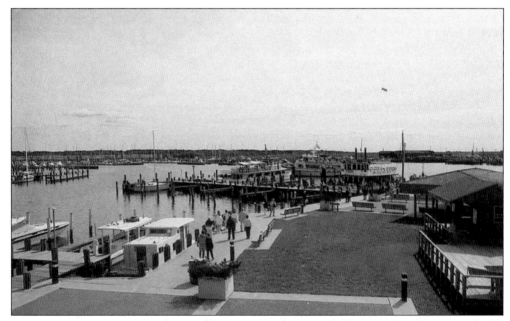

TOUR BOAT PIER. Many tour boats, offering passage from Crisfield to Smith and Tangier Islands, dock at the Somers Cove Marina at the tour boat pier, featured in the center of this view. The building to the far right is part of what was the J. Millard Tawes Museum and Visitors Center, now the Crisfield Heritage Museum, where visitors could see crab shedding demonstrations.

Ten

SMITH ISLAND

*S*mith Island was named for Capt. Henry Smith, who patented lands in both Maryland and Virginia, not John Smith, on whose map they are named the Russell Islands. During the Revolutionary War, the islands were Tory outposts, and their inhabitants made piratical raids against bay shipping and on mainland communities. This caused talk of rounding up the inhabitants of the islands and resettling them on the mainland, where they could be watched. However, by 1812, they had become loyal Americans.

The crab and the oyster are the foundation of Smith Island residents' livelihood, and the women of the island have formed a crab picking cooperative that now has the reputation of producing the best and safest crab meat in the state. The erection of a visitors' center and museum at Ewell and the building of a small motel there have made tourism the second industry of the islands.

REV. R.E. KEMP PREACHING ON SMITH ISLAND. Preaching on Smith Island was considered a "joyous moment." The congregation consisted of "old men and fathers of over four-score years, mothers in Israel and young people of all ages. The little sanctuary was capable of seating between one and two hundred persons." The church on the island was located on the thoroughfare near Ewell in a place called "Over the Gut." No one lives there now, but it was on a point with a wharf where many boats could tie up while their owners were attending services. The population was scattered over the island, not concentrated in three communities, and every hummock of over two or three acres was occupied. The church was a meeting place. This illustration is from *The Parson of the Islands* by the Rev. Adam Wallace.

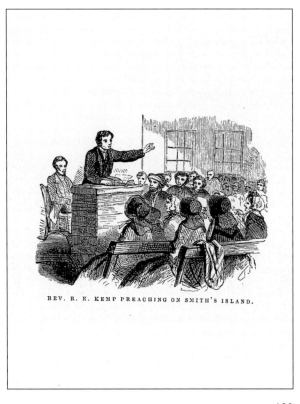

REV. R. E. KEMP PREACHING ON SMITH'S ISLAND.

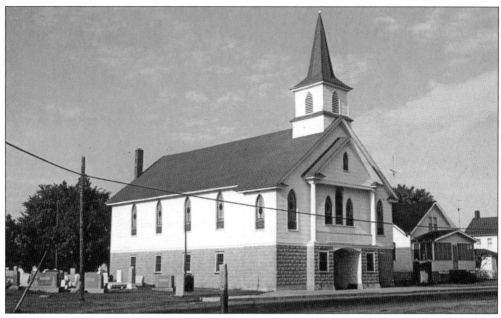

CORINTH METHODIST CHURCH. The original church at Ewell burned to the ground in 1937, at the end of the Great Depression, and caused the people of the community to dip into their almost-empty pockets to raise $12,000 to build the present structure. The parsonage is shown on the left side of the picture. The minister serves all three churches.

Wilson – Butler Tabernacle *Smith Island, Md.*

WILSON-BUTLER TABERNACLE AT EWELL. This is the site of the famous camp meeting on Smith Island. It is located at Ewell and was rebuilt after a disastrous fire in 1937 consumed all the buildings: the tabernacle, tents, boarding house, and cooking tent. The fire started in the church, spread to the campground, and threatened the whole community so that many people fled to their boats. However, the wind changed, and the fire died. Camp meeting week is homecoming week for the islanders. It is also a time for politicians to visit the island. The tabernacle is named after two of the preachers who served at the camp meetings.

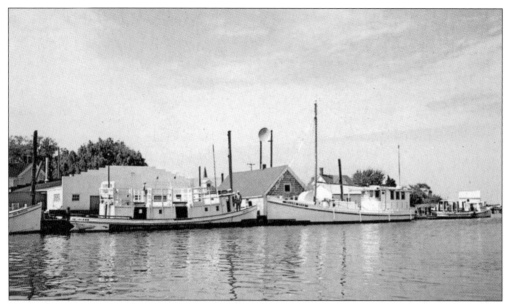

HARBOR AT EWELL. In the foreground is the *Island Belle*, and for over 40 years, she was the island's connection to the mainland. Every day she carried passengers and freight to Crisfield, and at 12:20 p.m., she made the return trip, stopping first at Tylerton and then Ewell. She has since been replaced by a bigger, faster boat. To the left is the *Island Star*, a school boat that carried high school students to Crisfield and brought them back at the end of the day. At one time, the students boarded in Crisfield and were only transported on Monday morning and Friday afternoon.

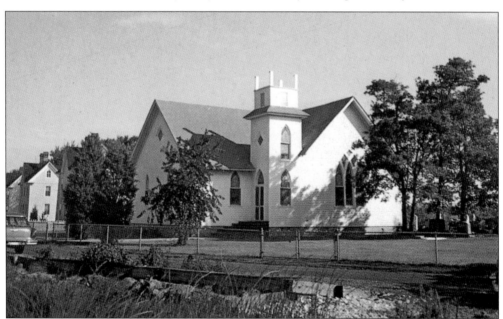

CALVARY METHODIST CHURCH, RHODES POINT. Rhodes Pointers built the first of three community churches. In 1895, the old school building was purchased and remodeled into a church. Residents got the original pews from the original church at Over the Gut. However, over time it became unsatisfactory, and in 1921, a new church was built.

CAPT. TYLER II. The *Capt. Tyler II* is the current ferry between Crisfield and the island. It leaves Crisfield daily at 12:30 p.m.

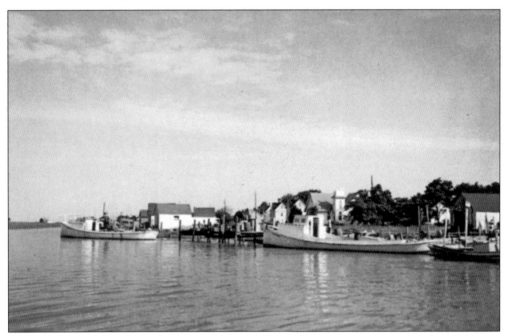

RHODES POINT. Originally known as Rogue's Point, the area's name was softened by the Methodists. Rhodes Point is connected to Ewell by the only road on the island, and it was the last of the three communities to get its own post office in 1907. John Jacob, one of the co-authors of this book, has a special feeling for Rhodes Point because two of his great-great-great grandparents are buried there.

UNION METHODIST CHURCH, TYLERTON.
When the decision was made to build a
separate church in each community,
Tylerton had just two communities, Tylerton
and Long Branch, with Oak Hammock
between them. This was where the school,
store, and ferry landing were located. The
decision was made to locate the church there,
and so it was built. The rising waters of the
bay caused Oak Hammock and Long Branch
to be abandoned, so in 1925, the church was
taken apart, its materials moved to Tylerton,
and it was re-erected with modern additions
costing $18,000.

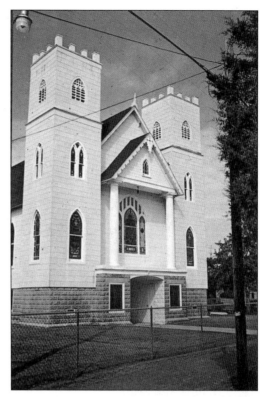

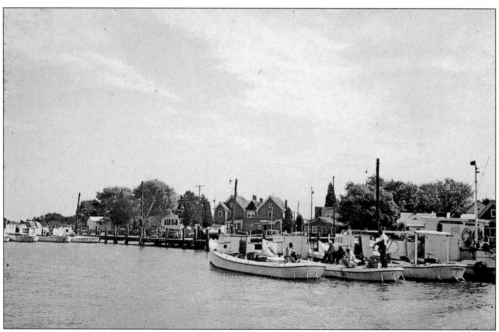

TYLERTON. This view shows just part of Tylerton. The house with the small tower in the center is
the largest building in the village except for the church, and the pier leading out into the water starts
from in front of the store.

POST OFFICE, TYLERTON. The post office at Tylerton was located in a store that was moved in 1925.

THE DEEP FREEZE. Winter has always been hard on Smith Islanders. Bay freezes have prevented watermen from oystering, and ice prevents boat traffic to Crisfield. The winters of 1918 and 1976–1977 are particularly memorable. In 1918, four weeks went by and food had become scarce when men set out determined to reach Crisfield. They finally made it after pushing their boat across the ice to where they could re-float it. In 1976–1977, the bay was frozen from December 28, 1976 until February 15, 1977. A National Guard helicopter airlift was the only way to move supplies to the islands. From top left clockwise are the following scenes: oil being airlifted; the residents of Ewell awaiting supplies; mounded ice between the islands and the mainland; and the frozen bay with Rhodes Point in the foreground.